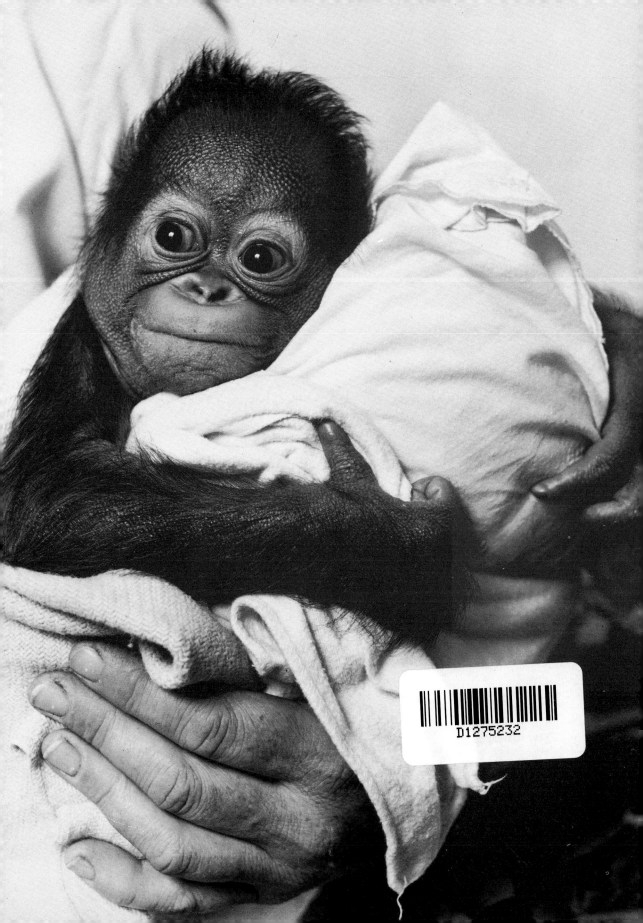

Tabby tonic

Do we really need all those pills we take? Perhaps a cat purring soothingly on the rug or a funny old mongrel wagging its tail as we come through the door would be even better?

Nowadays, doctors like Dr. Aaron Katcher of Pennsylvania University say that pets have a beneficial effect on those of us who are isolated, stressed or troubled. Animal companions fill our need for acceptance, for love and play, for security and self-esteem. Animals forgive us, don't judge us, don't stress us, and won't put us in an old people's home!

They are now being widely used in child therapy, in prisons and among patients recovering from mental illness. Even gazing at fish in an aquarium can lower blood pressure. But stroking a friendly dog can be as effective as many a modern drug.

In a study carried out in 1979, two scientists, Katcher and Friedman, found that patients who owned a pet were much more likely to recover from a heart attack. Stroking an animal causes a reduction in the heart rate. Simply by being there a pet helps a patient who is recuperating from an illness or operation, and it also helps to reduce stress.

J. R. Ackerley, the well-known writer and literary editor, suffered for years from a crippling depression, until the day when he took over a friend's lively German shepherd dog (the heroine of his book, "My Dog Tulip"). From then on his life became filled with the joy and new perception of the world which she brought to him.

More than a hundred years ago, the French poet, Lamartine, wrote, "Whenever a man is lonely, God sends him a dog." No wonder then, that about a quarter of the Americans who keep dogs take them to bed with them!

So who says we're not human?

John Doidge's animal photos

EXLEY

To my long-suffering wife Anne, who must many times have had second thoughts about the wisdom of marrying a freelance who has always been hellbent on taking pictures of animals

First published in Great Britain 1982 by Exley Publications Ltd, 16 Chalk Hill, Watford, Hertfordshire WD1 4BN

Photographs © John Doidge 1982
Text and design © Exley Publications 1982

This edition © Exley Publications 1986
Printed in Hungary by Kossuth Printing House

Distributed in the United States by
Interbook Inc.
14895 E. 14th Street
Suite 370
San Leandro
CA 94577
USA

British Library Cataloguing in Publication Data

Doidge, John
 So who says we're not human?
 1. Photography of animals
 I. Title
 779'. 32'0924 T R 727
 ISBN 1 85015 058 3

Introduction

As a photographer I particularly enjoy taking shots of animals, especially orang-utans who are almost more human than humans, they're so funny. I would be down at the zoo every day if I had freedom from the constraints of earning a living.

I have gathered the photographs in this book over twenty-five years of work as a freelance photographer, snatching the chance to take animal pictures wherever I could. There have been quite a few stormy passages when it looked certain that the ship would sink, but work on industrial assignments produced the cash to keep me going.

Animals have influenced my life in some odd ways. For instance, one cold December day in 1961 I was assigned by one of the Sunday papers to take pictures of Anne, a local Birmingham beauty queen who was offering a date in exchange for a bale of hay. The beauty queen's mother looked after old horses she had saved from the abattoir and was in desperate need of winter fodder for her charges. Hence the romantic offer.

The story worked wonders. Bales of hay and cash donations poured in. One lonely eighty-year-old even offered a truckload of hay – if she agreed to marry him and become a farmer's wife. Instead the foolish girl chose me, not knowing the full implications of becoming the bride of a freelance photographer.

Luckily, Anne can see the funny side of things. When I return home smelling strongly of the pungent scents of the Papuan rain forests, she just smiles, venturing a guess that I have been in close proximity to Cus Cus at the zoo. She holds her nose and starts the bath water.

Gary my son, has also had to bear with my life. I can be called out at any time of day or night. He's been to zoos since he was a toddler. Just recently, the keeper asked if Gary would like to see the orang-utan babies she was hand-rearing. Gary had never met these orang-utans before, but he has a sympathetic bond with young animals. He knelt and said hello to Tanga, and to my utter amazement the baby orang-utan came straight over, placed an arm round his neck and planted a kiss. No food or

enticement was used and the keeper was surprised, too. Tanga had not found another budy like Gary before. I quickly recorded the moment. It was sheer luck that I got this picture. I could never hope to repeat it, with all the time in the world.

But I'm a perennial optimist. I often set up shots and just hope something will happen. Most often I'm disappointed, but just sometimes it works. You've got to have endless patience, because animals are not like ordinary models. You can't say, "Go back and do that again". You can't even get the lighting right if they persist in sitting in the wrong spot. Quite often I'll spend two or three days at a zoo just waiting for one of those special moments.

I suppose my best pal is Big J at my local zoo, Twycross. That's Johnny the chimp; he knows me well, we've been on nodding terms for twenty years. Whenever he spots me he hastens to his quarters, scoops up a handful of dung and attempts a direct hit. If he succeeds he grins from ear to ear and squeals with delight.

With friends in the ape world like this, who needs enemies?

John Doidge

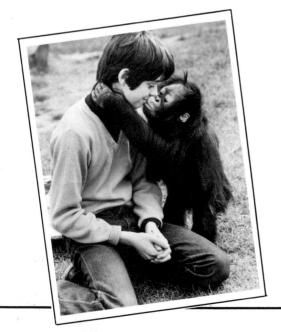

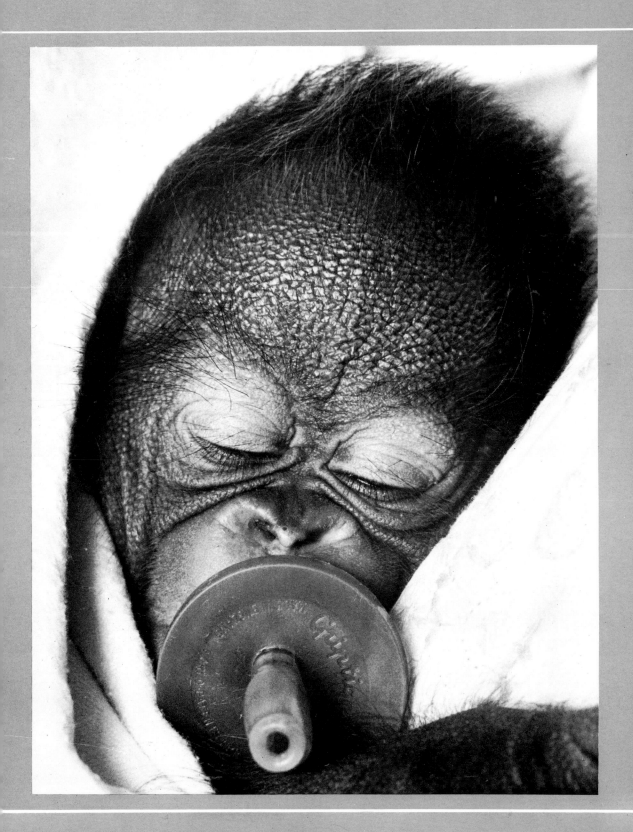

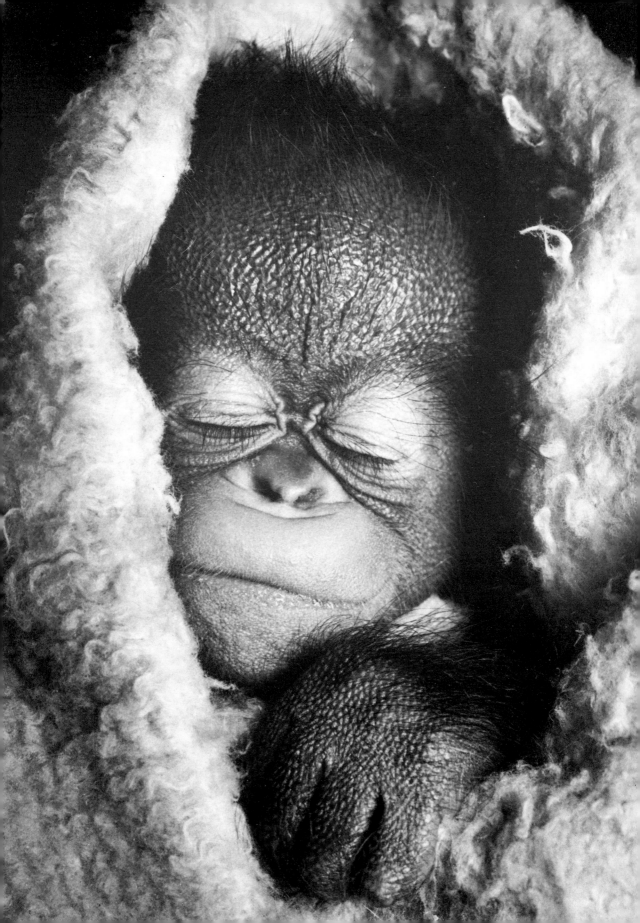

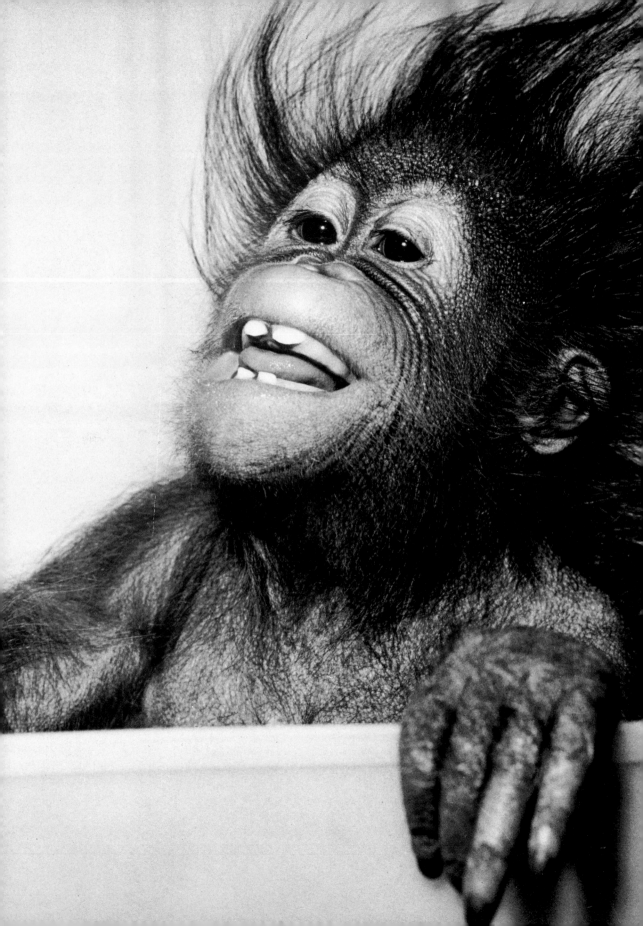

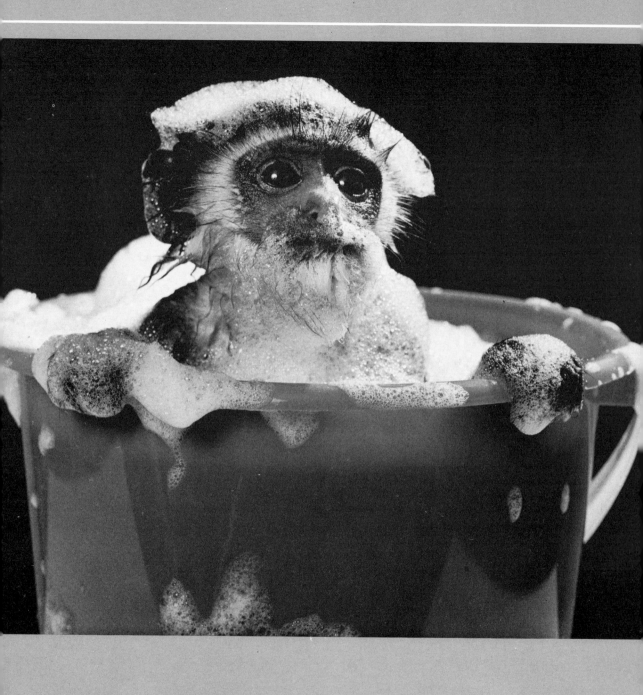

Abandoned

Their mothers didn't want to know, and zoo keepers and their wives had to become foster parents. In each case it was a total commitment — a baby monkey needs as much love and care as a human baby, twenty-four hours a day.

Baby Gibbons do not like being bathed but Oberon grew to love playing in his — he was definitely the centre of attention. He would squeal with anticipation when bath time came.

Oberon's diet is mashed bananas — served in teaspoons, of course.

Shula, a baby Lar Gibbon, has taken to sucking her thumb. After a bad start, she is now strong and healthy.

The Siamong Gibbon shown below is an endangered species. This baby weighed only one pound when she was three weeks old. Now, she is thriving on human care and feels warm in her romper suit. The danger period is over.

Zoos are playing a vital role in saving many endangered species. Some animals will not produce babies at all. But although primates do, the mothers very often do not know how to care for their young.

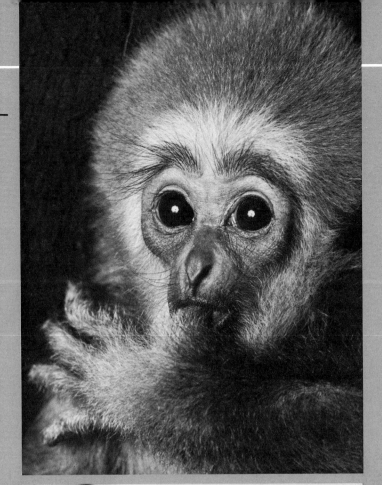

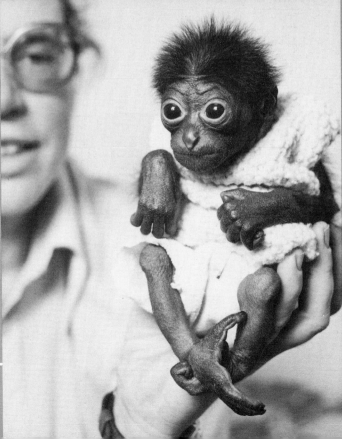

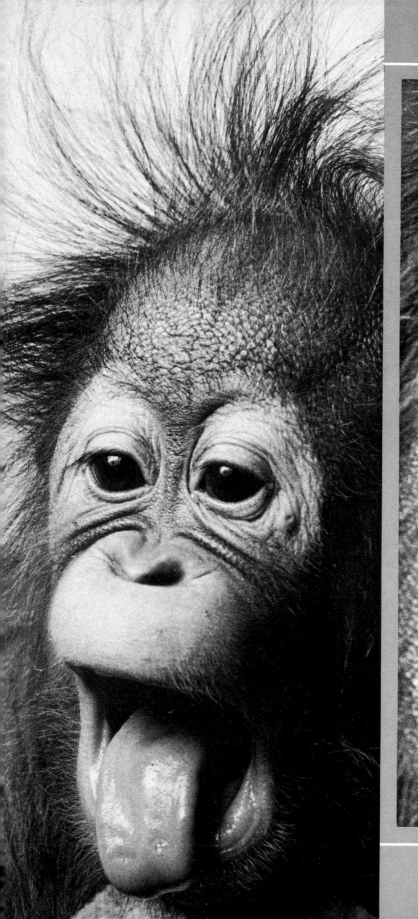

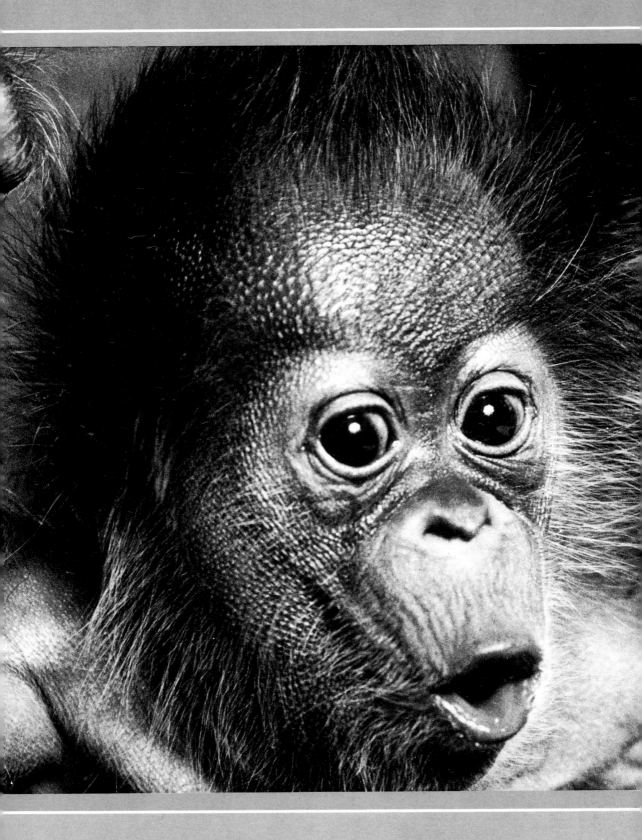

Pampered pets

It makes a good story that many a humble husband gets mince or fish sticks for supper while the family pet feasts on steak or salmon. But in many households this is exactly what does happen. No sacrifice is too great for that much-loved pet.

Mrs Violet Turner of Accrington, Lancashire, is retired and has to shop around for the cheaper cuts of meat for herself. So friends may well wonder when they see her buying a fresh, juicy pineapple at her local grocery store. It isn't for her, of course. It's for her rabbit.

"He gives me great comfort," Mrs Turner says. "When I give him a slice of pineapple, he looks up at me before he takes a bite, and I feel he is saying, 'Thank you'."

That is what pet-keeping is all about. People who didn't understand used to sneer at "sentimentality" about animals. Unfortunately, some doting owners go too far, and make their pets seem ridiculous. Rubber boots, designed to protect carpets from muddy paw-prints, and coats for pets that genuinely feel the cold, are a fine idea. But tuxedos, wedding dresses and pants, as advocated by Mrs Deborah Lewis of Chigwell in the south of England, top it all!

Wealthy pet owners can visit animal delicatessens or send their pets to luxury animal hotels, or even commission a composer to write an individual tune for their pet. They can pick up a heart-shaped bed, personalised stationery or beef-flavoured toothpaste. But can anything beat a Georgian-style love seat from Harrods – for a cool £205? Some people go even further; poodle mascara, eye shadow and nail varnish all sell like hot dogs in the States. In West Germany the over-privileged pooch patters off to bed in chic pajamas. And imagine the poor creatures that now have to make a weekly visit to a psychiatrist.

Did you know that in 1983 in the United States a record $5.5 billion was spent on canned and packeted cat and dog food? While in the United Kingdom during the next year 6.1 million dogs and 5.9 million cats together ate their way through £688 million (1,020,000 tonnes) worth of prepared pet food.

Dog-astrology is surely straining credulity too far – and yet all this kind of thing is perfectly harmless and gives a great deal of pleasure. People might scoff at the fulsome inscriptions in pet cemeteries, like the famous one in Hollywood, but each small grave shelters a loved one, whose loss is irreparable.

There is a great unity among animal lovers, from the middle-aged housewife who cleans other people's houses to earn money to buy hay for her herd of rescued ponies, to Queen Victoria, who was so fond of a tame sparrow that, when it died, she had it buried in the grounds of Windsor Castle, and had a headstone erected to its memory.

Strange bedfellows

The partnership between man and animal often enriches the quality of human life, and there are many unusual examples of close friendships.

The late Reggie Summerhayes, a horse trainer, built up such a relationship of mutual trust with his Arab stallion, Jaleel, that he used to lie down in the straw for a nap beside him. And that is just the sort of thing you don't usually risk with a frisky stallion!

Those cold and buttoned-up people who turn their backs on animals are missing out on a whole dimension of life.

Amazing bonds of affection can be formed with the most unexpected creatures. Little Annette Avers, of Portage, Wisconsin, doesn't cuddle up with her teddy at bedtime. Instead, every night the child snuggles down with her seven-foot pet snake 'on guard' on the pillow beside her. He dozes off, too – but you'd never know it, for snakes have no eyelids and sleep open-eyed.

New arrivals
at the zoo

John Doidge has made a specialty of photographing zoo animals and zoos have come to trust him. They appreciate John's professional approach and recognise that his appealing pictures are good publicity. He has built up such a rapport that zoos telephone to let him know when there's a new arrival ready and waiting for his roving camera.

Pacifier

Rupert the lion cub was abandoned by his mother at Southam Zoo, near Leamington in Warwickshire. Sometimes, in zoo conditions, however ideal, mother animals don't get to see other mums nursing their babies, and the instinct to suckle never surfaces. Zoo owner, Raymond Graham-Jones, took over the task of hand-rearing young Rupert. Babies' dummies are disapproved of these days, but Raymond found that dipping one in condensed milk was a handy way of pacifying Rupert when he got restless.

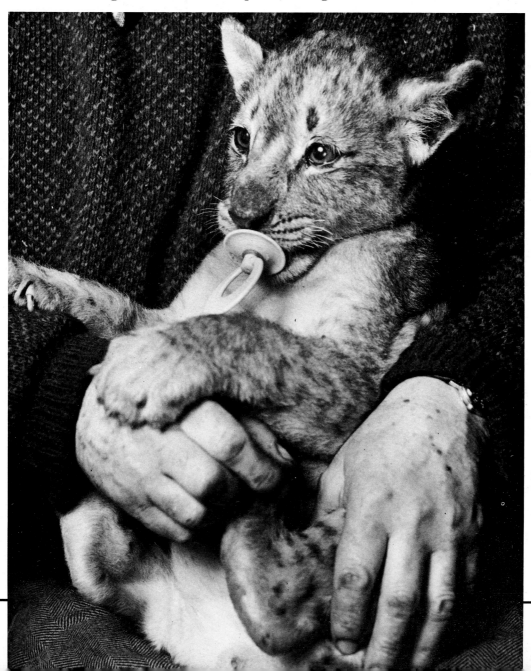

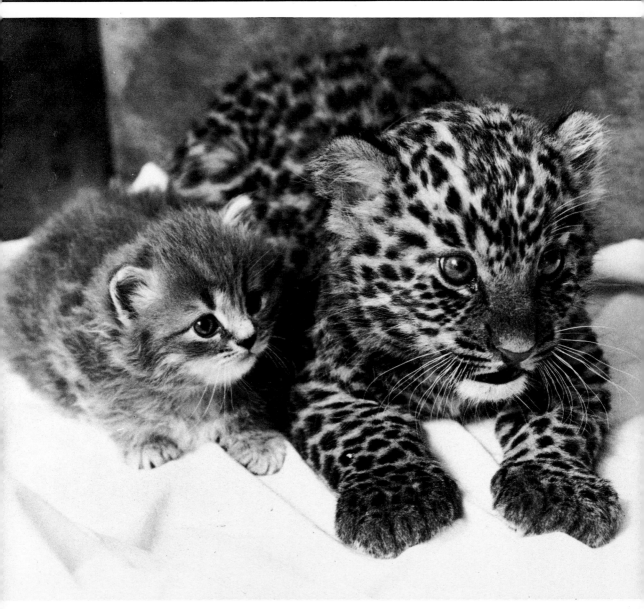

What future?

Poor little Jasmine's future was a bit of a question mark when her mother didn't want anything to do with her. So the wife of the owner of Southam Zoo took Jasmine under her wing.

The tail quirk was a lucky shot. Says John, 'Animals are not professional models; they will not strike a pose on request or do a retake, so it is important to remain sensitive to their changing moods in an effort to anticipate when a shot will develop.'

Like father, like mother, like son

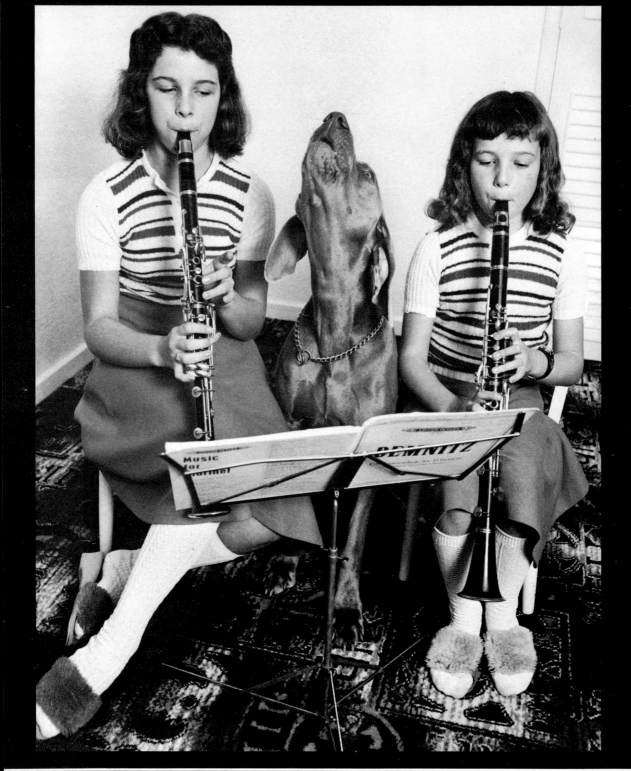

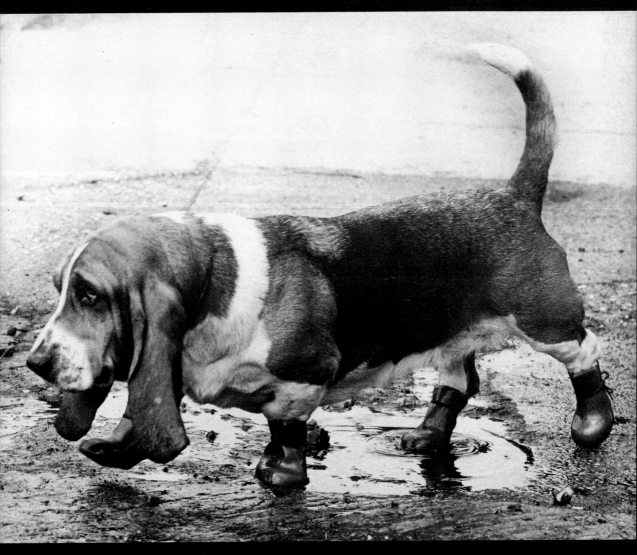

A howling success

Weimaraners — the silver ghost dogs — hailed originally from the court at Weimar, in Germany, around the end of the 18th century. Perhaps that's where Duke got his taste for Wagner! Here he is, making sure Zoe and Dana Biddle get their crotchets and quavers right.

Bootsie and Sludge

There's nothing like a pair of wellington boots for splashing about in the mud. Except two pairs of wellies, if you're a Basset Hound called Arrow and your mistress is fed up with paw-marks on her carpets. But that still leaves the problem of what to put on those dangling ears!

The cost of loving

So great is the hold pets have over their owners that no sacrifice, it seems, is too extreme. Some years ago, 59-year-old John Kitchiner, a London engineer, offered to barter his glamorous Mercedes car for the safe return of his tabby cat, Lucky.

"I like my car, but I love my cat more," Mr Kitchiner explained. "My wife and I don't have children, so I suppose we spoil our three cats. And Lucky is the one we love most."

In 1981 Mrs. Beatrice Anson battled to gain possession of two eight-inch toy poddles, Lulu and Ivan, from her estranged husband, George Souvatzoglou. When George was out one day she hurled a brick through the kitchen window to get the dogs. She then spent three days and nights motoring through Yugoslavia, Italy and France to return home to England. The dogs then stayed in quarantine for six months – at a cost of nearly £1,000. Mrs. Anson is a nurse, yet she has spent her hard-earned money on her dogs instead of herself. "I will die for my dogs if I have to ... I know it sounds silly, but I love those dogs like I could my children."

In 1967 Miss Elspeth Sellar turned down an offer of $3,150 from an American breeder for her British champion white Persian cat, called Coylam Marcus. An even larger offer was rejected in 1972 by Mrs. Judith Thurlow, who was offered $21,000 for her champion greyhound, Super Rory.

Some pet owners have gone so far as to leave all their money to their pets. In June, 1963, Dr. William Grier left his entire estate of $415,000 to his two fifteen-year-old cats, Hellcat and Brownie.

We value our pets so highly that we want them to have the most sophisticated medical treatment to prolong and improve their lives. American specialists pioneered the fitting of heart pacemakers to dogs, and, in March 1980, an eighteen-month-old Labrador named Major Disaster, belonging to Mrs Vivienne Harcombe, became the first British dog to have this life-saving operation. Richard Palmer and his team carried out the £1,500 operation free of charge.

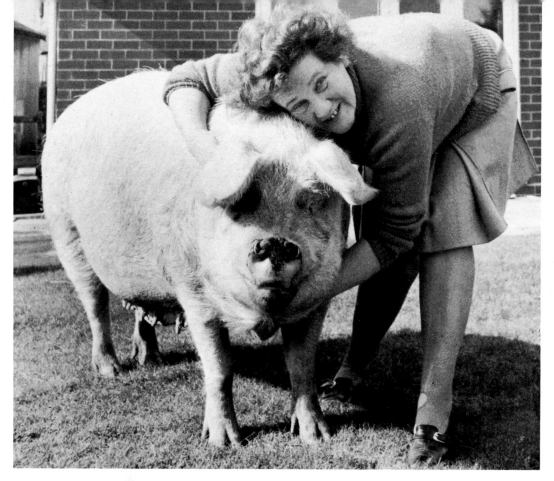

A pig to tea

A lot of people happen to think that pigs are really rather fun, but few of us would go as far as Mrs Olive Turnbull, who keeps fat pink porkers as pets.

Olive is the wife of a top civil servant, and when they moved into a new house in the Shropshire village of Darliston and she was alone all day, she felt bored and lonely.

The only friendly faces were the pigs in the farmer's field next to her garden, and although she knew nothing about pigs, she began feeding them scraps and talking to them. Soon they came running when they saw her, and she ventured over the fence and even taught her favourite, Chatterbox, to sit (shades of Barbara Woodhouse!) and then to kneel.

The day came when Chatterbox gave birth to a litter of squeaking piglets. It saddened Olive that a little runt, which she named Little Boy, looked unlikely to survive. The farmer said gruffly, 'There's nothing I can do, it's nature.' Then he added the fateful words, 'Take it if you want it, but don't come back crying if it's dead in forty-eight hours.'

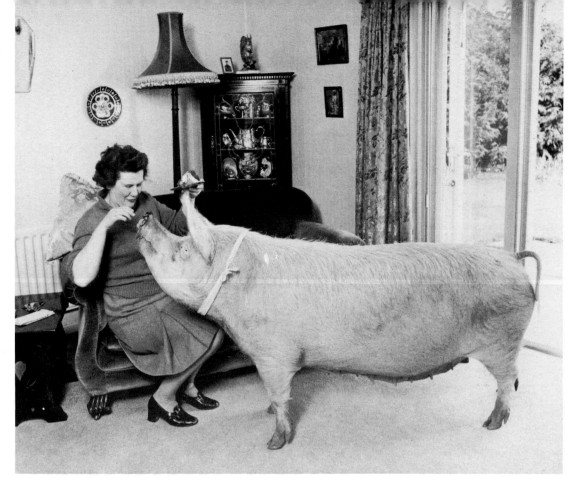

That started it all. Olive wrapped up the puny mite in her coat and ran home with it. Little Boy thrived on milk, glucose and brandy — and affection. In no time at all, he was house-trained, going for walks on a lead and watching television.

Olive was so delighted with her pet that she decided to expand and breed pigs as a hobby. She sells the litters privately, never at auction, and her pets are still allowed into the house. They get Christmas stockings and Easter eggs.

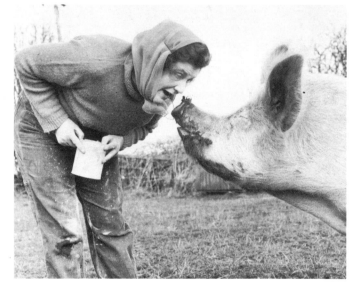

That's my mother?

What exactly does go on behind those furry ears? Maternal instinct makes animals good mothers, but why do they sometimes "adopt" an orphan of another species and even suckle it?

There is the case of three orphan lion cubs in the Kruger National Park, South Africa, who were reared by a three-year-old bull terrier, while a litter of young leopards had a chimpanzee for their foster mum. And another chimpanzee has taken on a professional motherly role as a vet's assistant: Chosuke, an eight-year-old chimp, not only carries patients to and from the table, but also holds the sick animals still so that the vet can carry out an examination. The animals are far less nervous when Chosuke holds them.

TV vet James Herriot relates how a practical farmer's wife put a stray kitten in with a litter of nursing piglets. Sharp claws kneaded the sow's tender dugs, and still she did not reject the furry cuckoo in her sty.

One Labrador retriever whose close companion, a terrier, had died, set about replacing his friend. He stayed in the kennel for three days. Then, one day at sunset he entered a chicken run, and returned to his kennel with a squawking pullet. There the reluctant pullet was made to spend the night. The next morning, the dog took the pullet back to the run, and from then on, collected his new friend each night. After three days the pullet had adjusted to its new routine and the dog stopped moping.

The occasional perils of being a photographer. When this picture of a tiny marmoset appeared in the 'Daily Mirror', John was promptly visited by two burly detectives. A reader had claimed the ring was part of the proceeds of a burglary. John solved that one with recourse to his ample files of early engagement pictures.

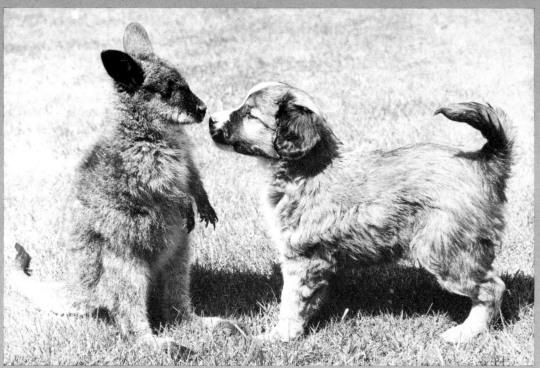

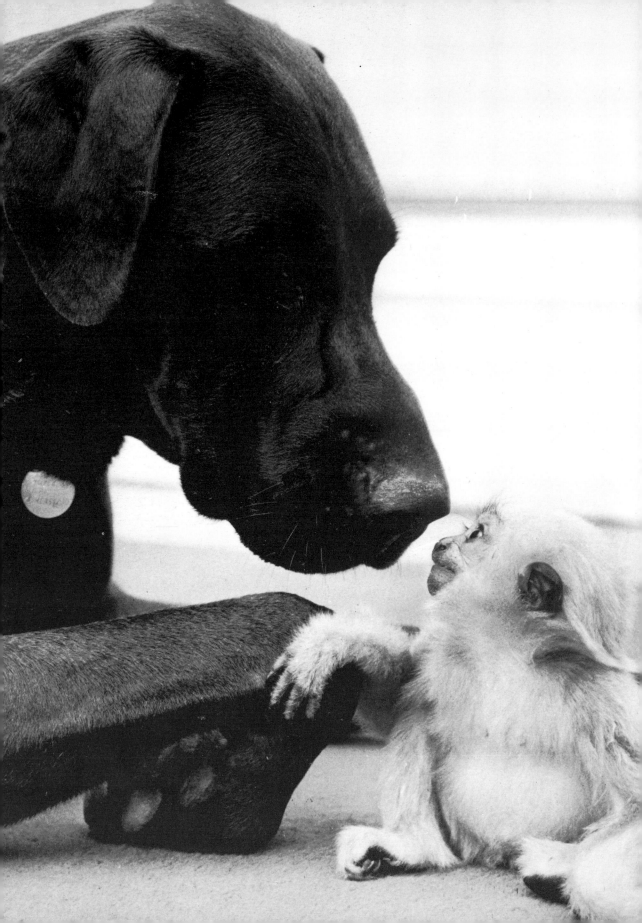

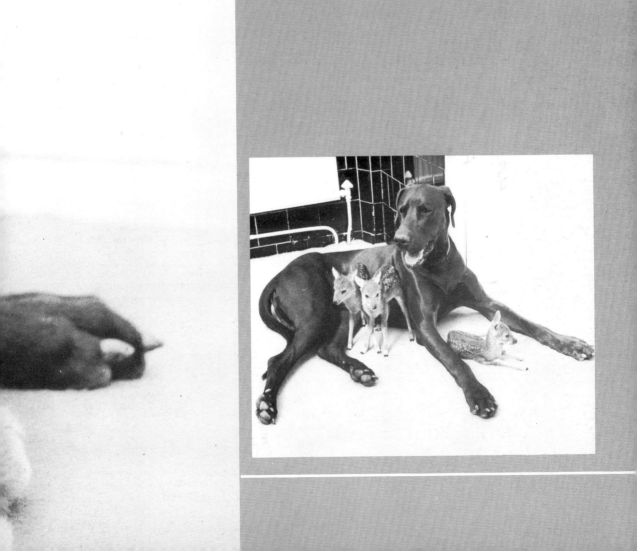

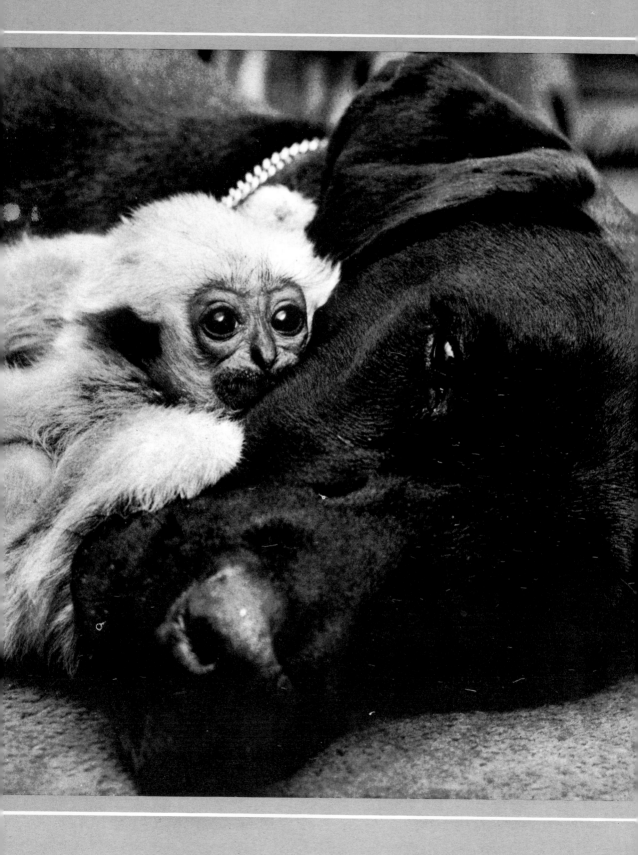

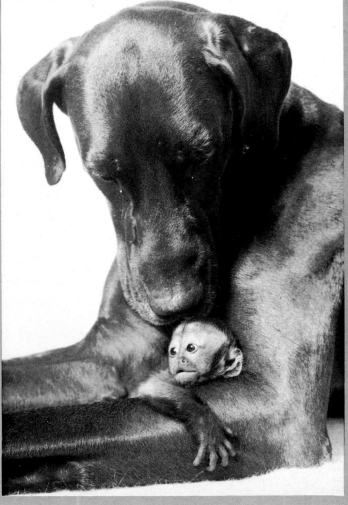

Unlikely companions

Almost every week the newspapers report some unusual animal friendship. A fluffy duckling nestles between the chunky paws of a St. Bernard, a cat and a fox curl up together, but some liaisons are positively stranger than fiction. One such "partnership" was discovered by a farmer in Cape Town, South Africa. He suspected that someone was stealing the milk of one of his cows, so he stayed up one night to catch the culprit. After some time a long ringhals (a flat-headed, deadly snake, like a cobra) came from the scrub and began drinking from the cow, which complacently allowed the snake to drink. When the snake had finished drinking, the cow turned and licked its head. Similar cases have been reported, including a crocodile who used a cow as his milk-bar.

The most bizarre "mess-mates" are those where, normally, one is the natural prey of the other. Old-style circuses used to put on tableaux of lambs and goats herded in with lions and tigers, but there was nothing spontaneous about such displays. Sheer human dominance and, frequently, cruelty, held together these unnatural set-pieces, when every instinct in the lamb was screaming for it to escape.

The pig who thinks she's a dog

Sally the piglet thought she was a long-haired dachshund, all right, because she'd been brought up with a litter of them. She was nearly as long as a sausage-dog, wasn't she? She took her share of the bottle, just like her brothers and sisters, didn't she? Even if she still wanted more when they'd lost interest, and even if she was a teeny bit sturdier than them.

The question is – did the baby dachshunds think she was one of them, or did they know all along that she was a greedy pig?

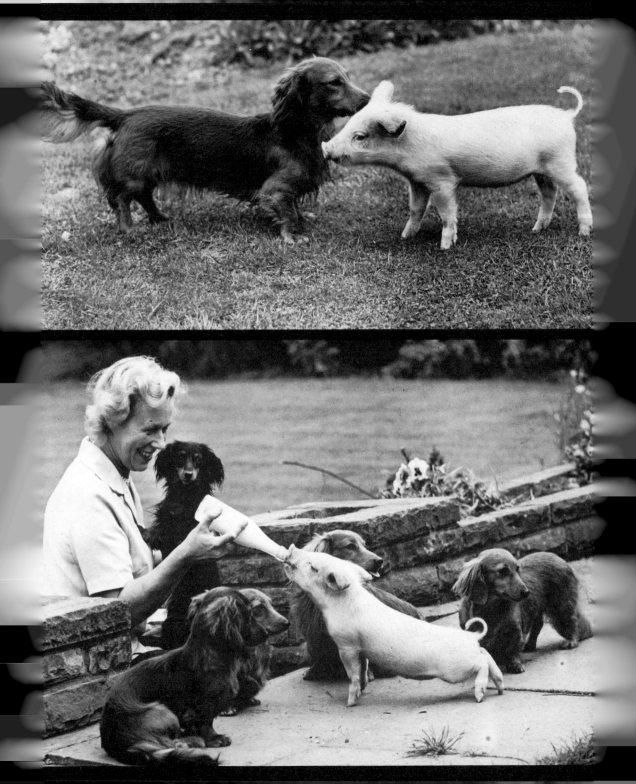

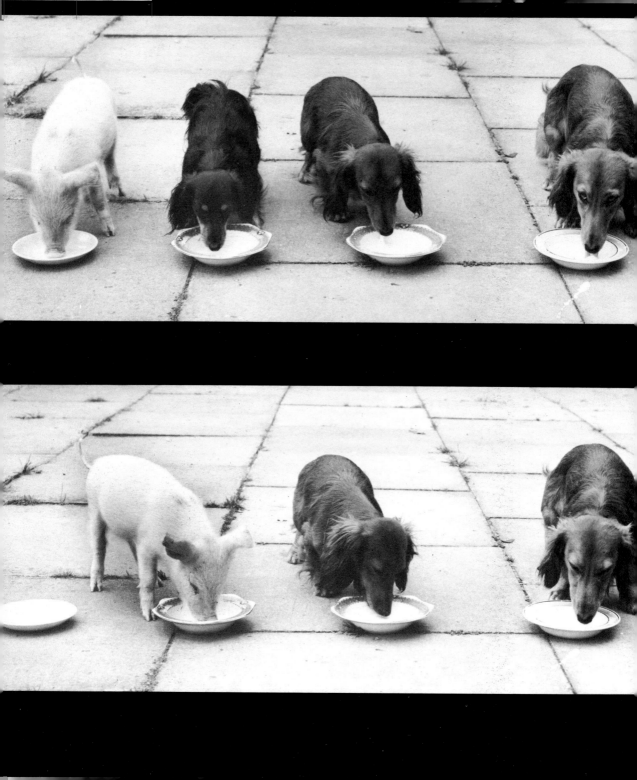

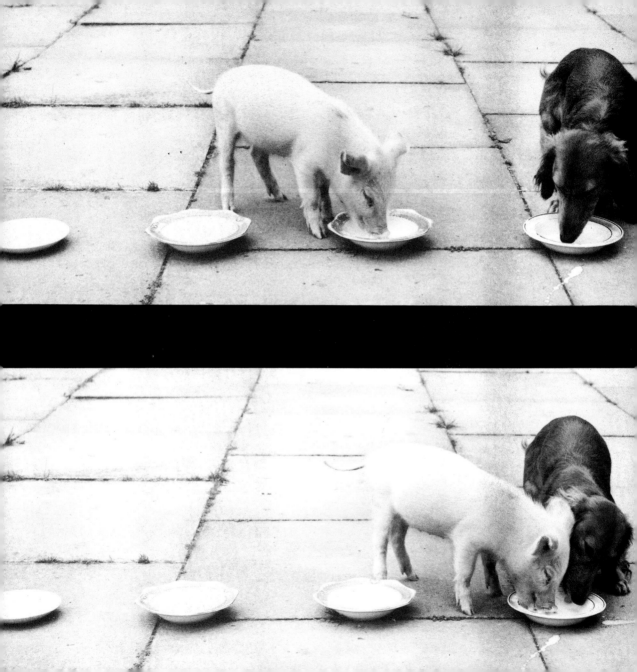

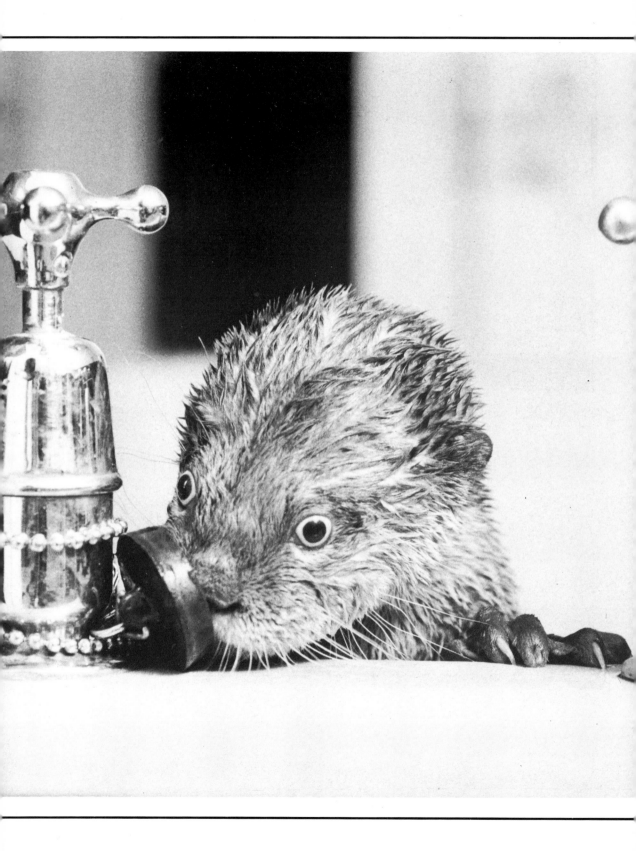

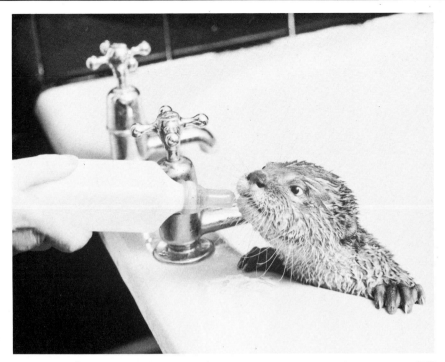

Totty the otter

Totty the baby otter was having a
tottering time with his mother,
who was so proud of him that she
kept lugging him out in the cold to
show him off. So Twycross Zoo
director, Miss Nathalie Evans
decided to rear him by hand at her
home.

In the wild, otters teach their cubs
to swim by the sink-or-swim
method, but Nathalie dunked the
baby otter more gently in her bath,
gradually making the water deeper
and deeper.

A small snag was that Totty kept
pulling out the plug, for fun, and
once gave himself a nasty fright
when he got caught in the
whirlpool.

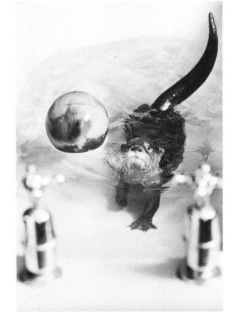

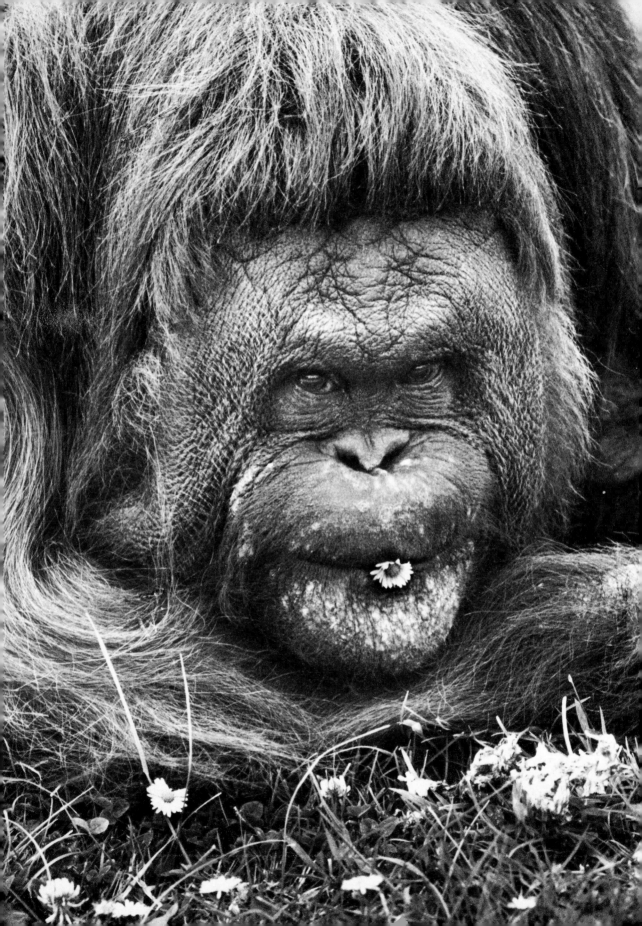

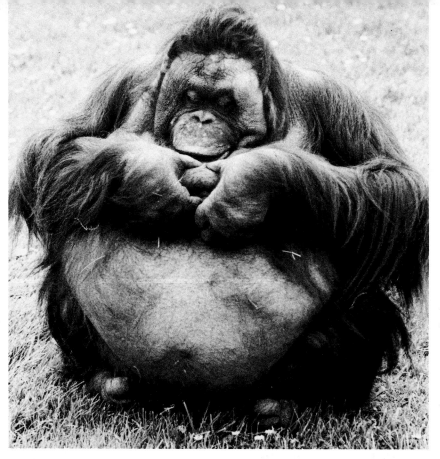

Twiggy

When the three-year-old orang-utan arrived at the Twycross Zoo in Leicestershire, she was so fat that she was instantly named Twiggy, as a parody on the famous – and slender – Sixties' model. Twiggy (the human version, that is) was not offended – in fact photographs of the two Twiggies were soon being sent back and forth, in a friendly exchange. And she has taken an interest in Twycross Twiggy ever since. The years passed and fat Twiggy waxed fatter. Too fat. The zoo vet put her on a strict diet – no more bananas or bread, just lots of lettuce and oranges.

Flower power

When he was awarded a prize for 'Flower Power' in the annual Press Contest, one of the Cockney photographers present at the prize-giving came up to John Doidge and said 'Cor Mate, what did you do then – stick a plastic daisy in 'er mowff then?' But that just isn't John's style. Even if he waited for months, he could never repeat this shot. It was just luck that Twiggy put the daisy in her mouth just as John had the camera ready and waiting. He insists, modestly, that any amateur armed with the right equipment, similar patience and a huge slice of luck, could have caught the moment.

As for any budding John Doidge having the idea that captive animals are so tame that the keepers will let you into their enclosures – forget it! You have to get used to working through wire mesh, or glass, and in the case of orang-utans and gorillas, armour-plated glass, with all the problems that they bring. All zoo keepers have a healthy respect for their charges. Hand-reared chimps, in particular, when they reach adulthood, are unpredictable, and John remembers Jimmy Chipperfield, of circus fame, telling him that he'd rather face a big cat than a fully-grown chimpanzee.

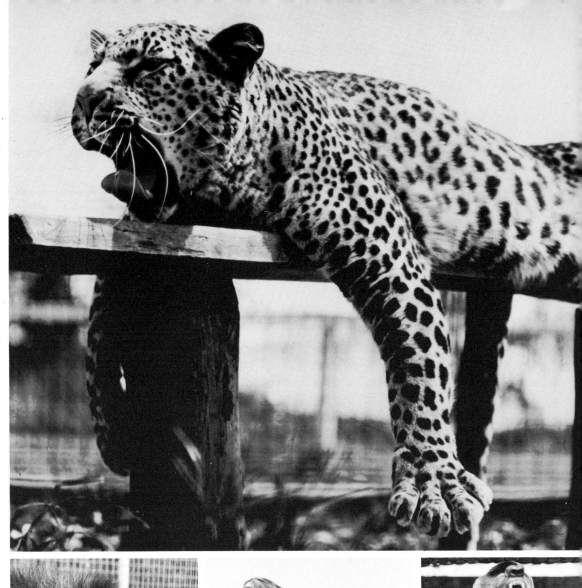

Lazybones

Nishka, the resident leopard at Twycross Zoo, wouldn't oblige John Doidge with any interesting poses, one languid sunny morning . . . Sometimes John feels like a big game hunter stalking his prey, adjusting the equipment and ready at all times to respond instantly.

The drowsy big cat stared back blankly at him and time passed until they called John in to lunch. Some instinct made him linger on — until suddenly all the ingredients came together as Nishka decided that being photographed was such a big yawn that the only thing to do was to put on her celebrated rug-imitation. John's photograph appeared as a full page as 'Picture of the Week' in Paris-match.

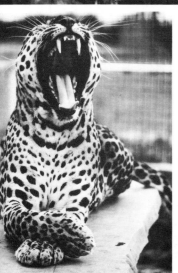

Friends in need

On many occasions, human beings have witnessed extraordinary scenes where animals have stood by or helped one another in times of danger or impending death.

In an article published in the East African Wildlife Journal in 1964 the story was told of three elephants who had been shot. They were part of a herd of thirty animals. The herd trumpeted wildly, and with "incredible determination and complete disregard for their own safety" tried to lift up the three dead animals. For more than half-an-hour the elephants persevered, using their trunks and pawing in an attempt to move the carcasses. Noisy and angry, they smashed foliage and threw clumps of grass up into the air. They returned three times trying to raise their companions.

Loyalty has been observed among all sorts of animals. In 1924, a miner saw a rare sight: two rats were walking, each one holding the end of a piece of straw in its mouth. The collier realised that the second rat was blind, and was being led by his sighted companion.

Birds, too, show great loyalty to one another. The story is told of a common house sparrow which caught its head in a crack in a wooden garage. While the bird struggled desperately to free itself, another sparrow hung onto its tail before falling to the ground. It flew up several more times, each time hanging onto the trapped sparrow. Another sparrow then came to help the first rescuer. After several attempts, the pair succeeded, and the bird flew free.

Animal aid

Some animals can be trained to help Man in the most ingenious ways, by tapping their natural abilities. Many of them, like good doctors and nurses, go far beyond the call of duty.

Guide dogs for the blind give their services so willingly and

show such wonderful understanding that they silence any animal hater. They are the ultimate answer to the anti-dog brigade.

Less well known, but just as miraculous, is the achievement of Dr. Mary Willard, of Tufts New England Medical Centre Hospital, in Boston, Massachusetts, who selected six tiny Capuchin monkeys and taught them to help disabled people. Robert Foster is a quadraplegic – paralysed in both arms and legs – but life is much easier for him now. His little monkey puts food in and out of a microwave oven, takes bottles out of the refrigerator, opens them, and then holds a straw in place for Robert to drink. It can open and unlock doors with a key, take a disc from an album and put it on a turntable, and even brush Robert's hair. Suddenly, Robert's life is fuller, he is more independent, and he has a constant and loyal companion.

Monkeys get up to all sorts of clever monkey-tricks. A train crossing in South Africa has a special gate-opener – a baboon! And on an Australian sheep farm a nimble rhesus monkey earns his keep by picking burrs out of the fleeces at shearing time.

Helping his crippled master came naturally to Gyp. No one ever needed to teach *him* what to do. Angus Spence, who suffers from multiple sclerosis, lives alone in the remote Scottish village of Birsay, and bought the intelligent collie as a companion, ten years ago, little knowing then that Gyp would turn out to have amazing powers. Simply through watching Angus's struggles to cope with the daily routine, he reasoned out ways of making things easier for him. He ferries shopping lists to friends, carries back food, pads in with coal for the fire, lump by lump, and fetches clothing to Angus's side. He knows the right time to bring his pills, too. Angus's doctor, Dr. Robert Hazlehurst, confirms Gyp's skills, having seen the collie pull the bedclothes back to make it less difficult for Angus to get into bed.

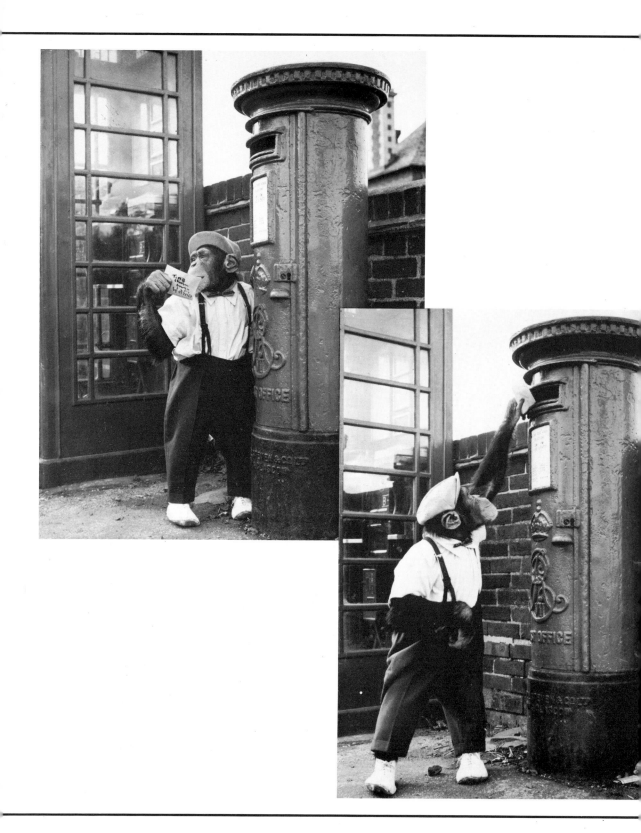

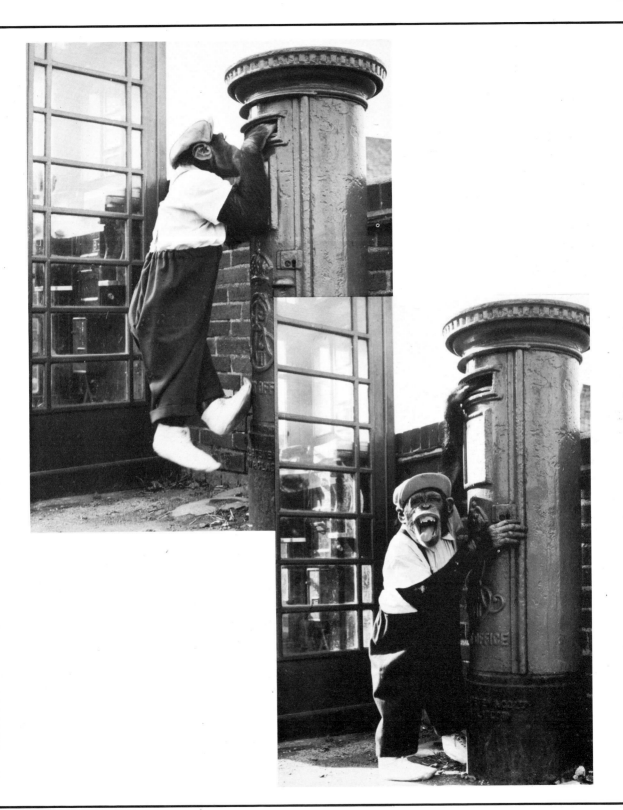

Professional chimps

These lovable British chimps
are members of a famous team
of professional chimp-actors
who appear in television tea
commercials.

Their trainer, Molly Badham,
and her friend, Nathalie Evans,
founded and built up the
outstanding collection of
primates at Twycross Zoo.
They formed the habit of
dressing up their chimps in an
attempt to keep them warm,
long before stardom was even
thought of. Rearing the delicate
babies proved to be full of pit-
falls.

As for the tricks – they kept
them amused and out of
mischief. All chimps need
skilled handling as they are
prone to be jealous and pack a
nasty bite.

The actors were temperamental
during filming for the series of
TV spots and tried to upstage
one another. They didn't mind
how many times the scenes
were reshot, though, and
became slicker and sharper with
each take.

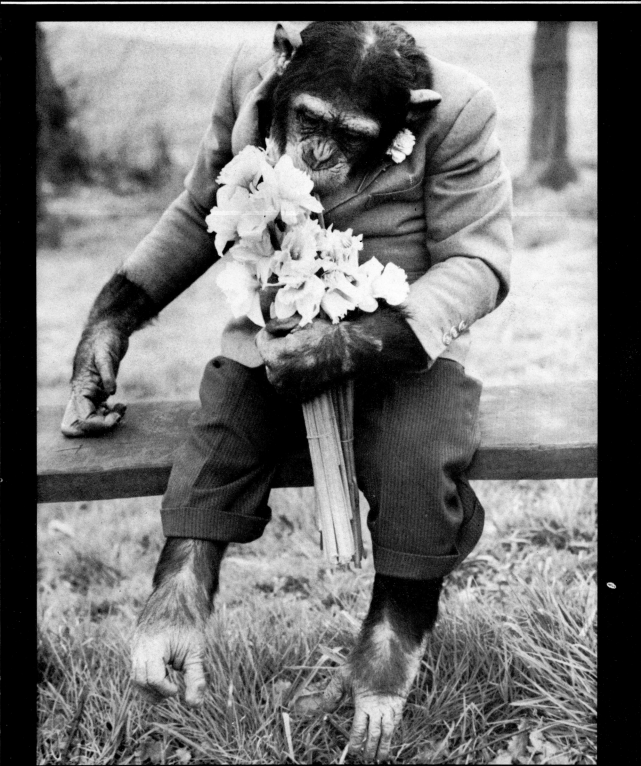

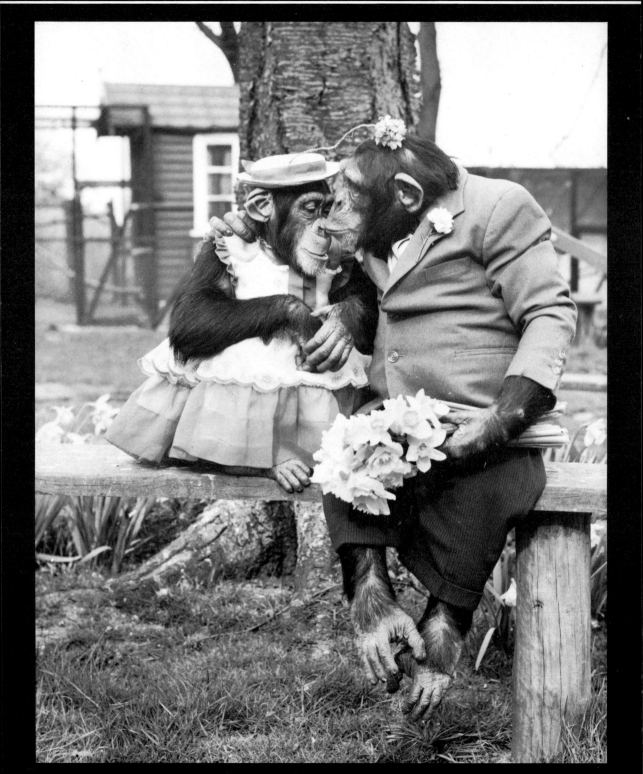

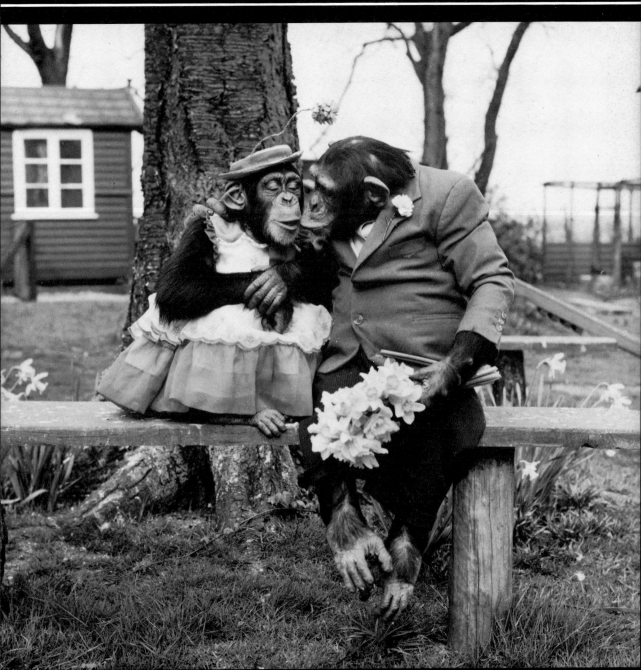

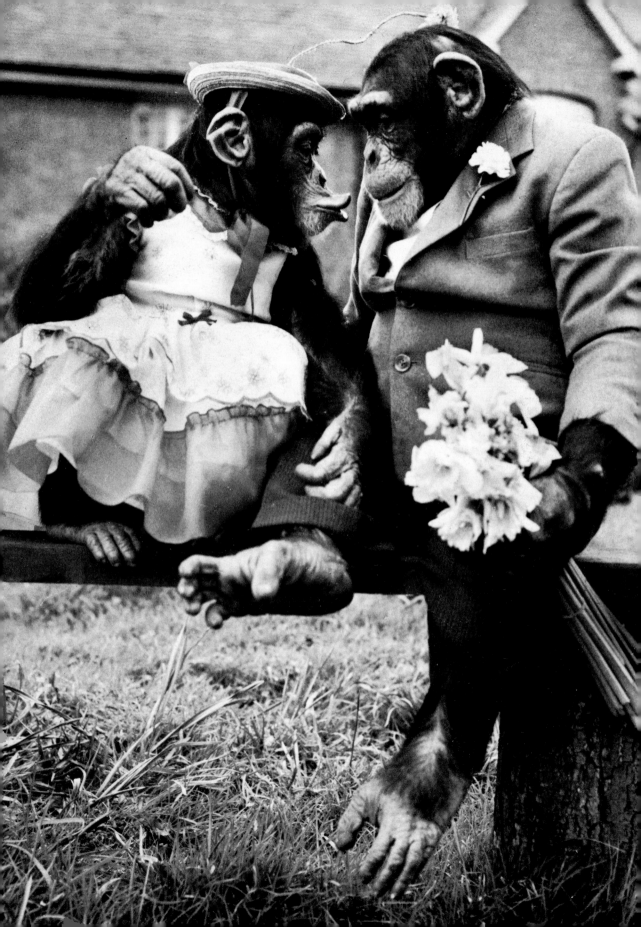

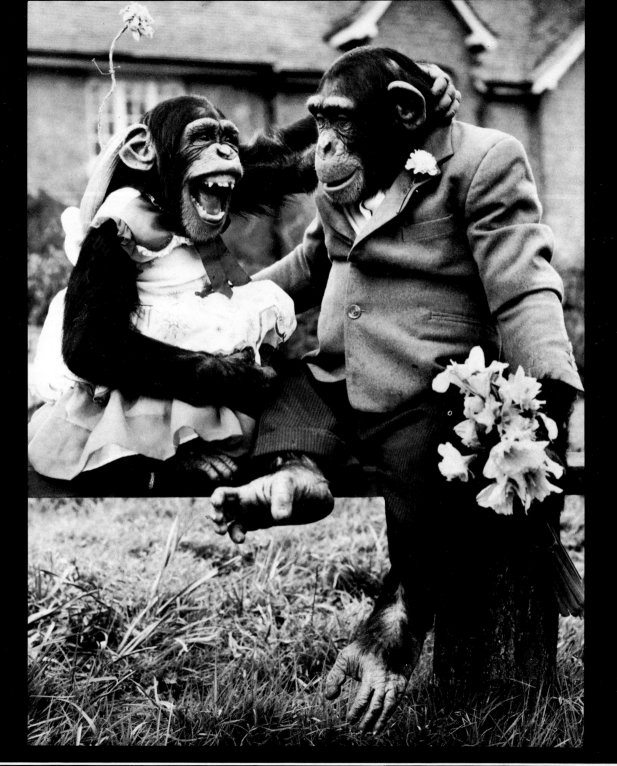

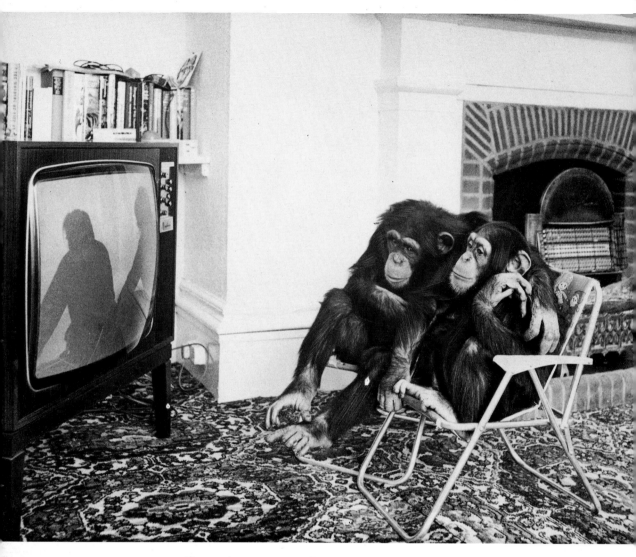

Not their cup of tea

These two chimps, Noddy and Choppers, were in training for their parts in television adverts. During breaks they were allowed to watch television in the lounge of Twycross Zoo director, Mollie Badham.

They didn't like their first choice of programme — obviously too dull.

They prefer cartoons. Or <u>really</u> <u>noisy</u>, dramatic thrillers and cowboy films!

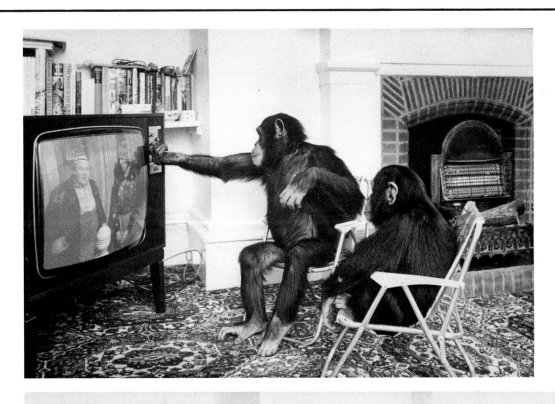
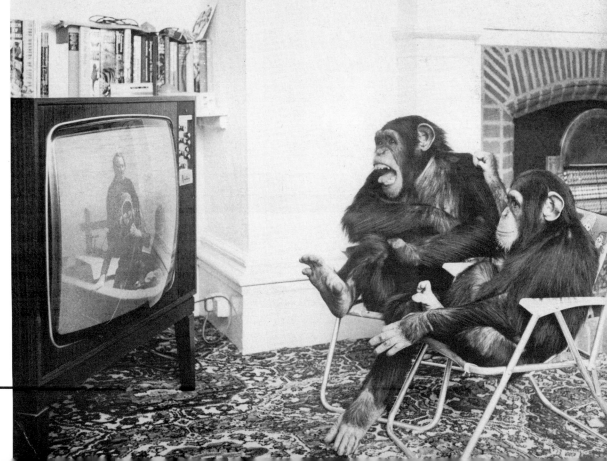

Brighter than you think

Do animals reason? Or is it all instinct? Most scientists today accept that animals are capable of some degree of intelligent planning.

There is no other explanation for the actions of the killer whales who could distinguish between a harmless fishing boat and an armed whale-catcher. It happened in the Antarctic, where a Norwegian whaling fleet was called in to help a fishing fleet whose catch was fast disappearing down the maws of a flotilla of twenty-foot killer whales. The whalers obligingly sent in three boats, and one of them fired a single shot from its harpoon gun. It hit one whale. Within minutes, all the whales had vanished from the vicinity of the whale-catchers. But they carried on foraying around the fishing boats, even though the catchers and the fishing boats looked identical, since they were all converted World War II patrol boats. From a whale's eye view, they all had the same silhouette, and they all made the same engine noise. The only difference was the small harpoon gun on the bow of the whale-catcher. Therefore, the whales effectively distinguished the boats with the sting from the unarmed ones, in spite of the fact that a gun is an alien modern object, and – even stranger – communicated the danger to one another.

The higher animals – the apes – are adept at working things out and forming a plan of action. When the big male gorilla at Zurich Zoo felt unbearably lonely behind his unyielding bars, he decided to do something about it. People used to play with him and cuddle him, but now there was no one to hug.

He was particularly fond of a girl keeper who was kind to him and spoke softly to him as she went about her duties. One night, she was the last to leave the building. As she passed the gorilla, she was horrified to notice that he seemed to be caught up in a length of wire, and could not move. She ran round to the back of the cage and unlocked the door, cautiously, to get a closer view. To her amazement, the cage looked empty. She leaned further in. Whoosh! The lonely gorilla, grinning and

jubilant, plopped down triumphantly from his hiding place and grabbed her. All he wanted was to cuddle and hold her – and so he did, until the girl was rescued unharmed in the morning. He had remembered an occasion when he had been trapped by wire and his keeper had entered the cage to free him, and had reasoned out that pretending to be in trouble again was a way to get some company.

Identity crisis

Encouraging animals to be friendly to human beings isn't *always* a good thing if the end result is to make the animal think he *is* a human being. That is why Guy the gorilla died a lonely bachelor, and why pandas prefer their keepers to prospective furry piebald bridegrooms!

Cholmondley was a sad case in point. He was a large, pet chimpanzee, who lived the life of Riley at his owner's home, eating at the table with him, getting through twenty cigarettes a day, enjoying a bottle or two of beer and always dressed in classy men's clothes. Not surprisingly, he formed the fixed belief that he was a gentleman of some distinction, and when he was reluctantly consigned to the London Zoo, Cholmondley found it little better than a prison camp, devoid of the comforts which he expected as his right. The chimpanzee made a series of well-planned and brilliantly executed break-outs, during one of which he calmly boarded a bus. When they tried to chloroform him for a medical examination, he inserted his finger in the gas-tube and glared back at his persecutors. In the end, for safety reasons, he had to be shot, making his killers feel like murderers.

If we can only find the key, and avoid exploitation, we can draw upon the natural qualities of remote-seeming animals like cats, which appear to have infinite wisdom.

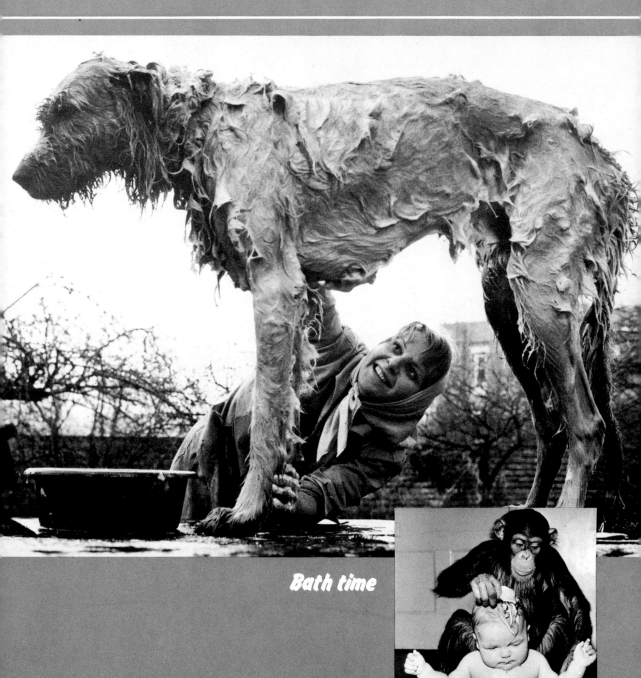

Bath time

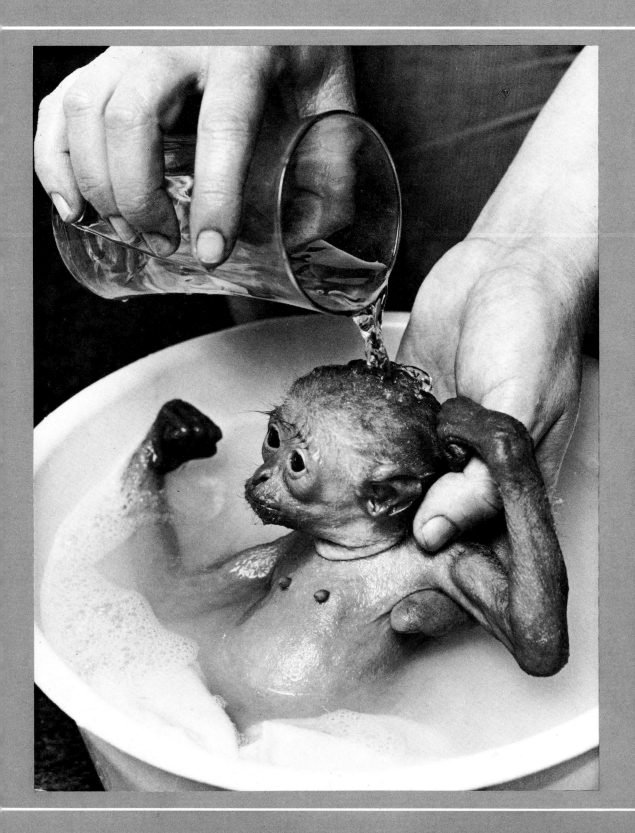

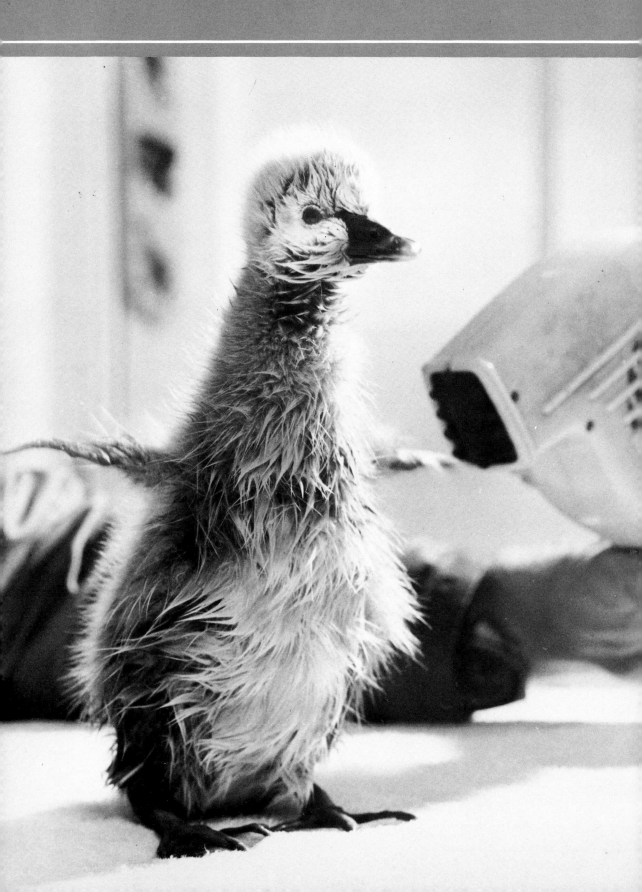

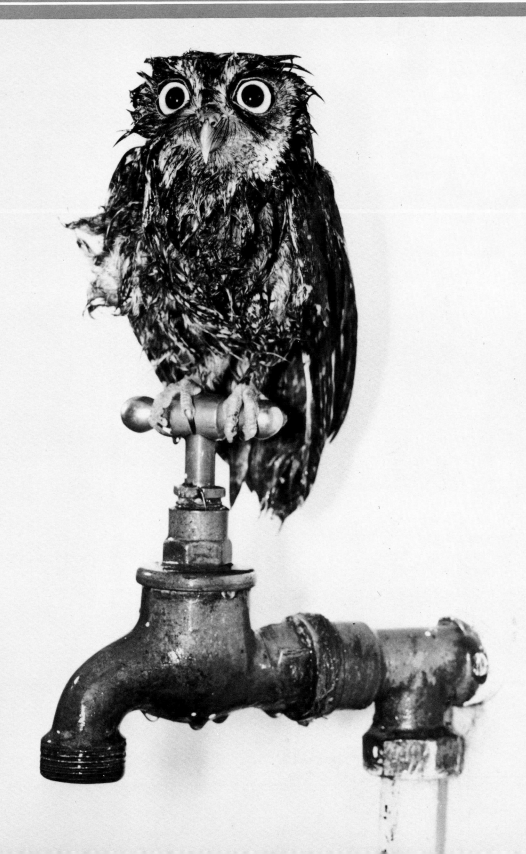

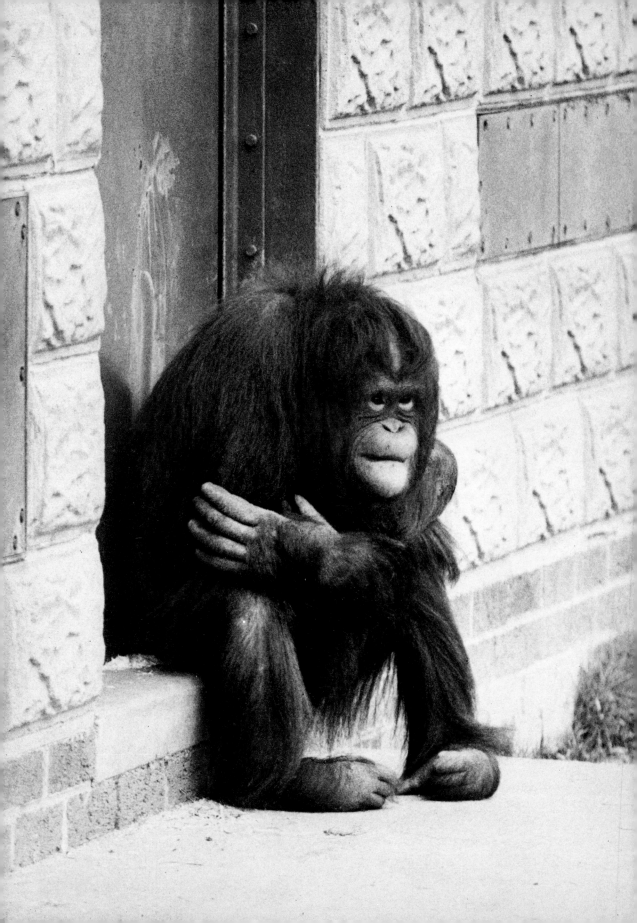

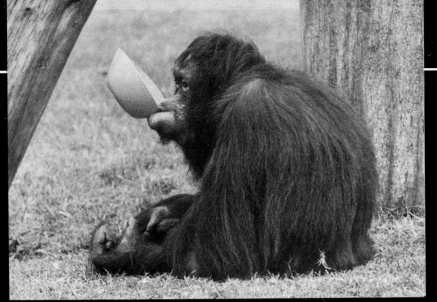

Almost human

The picture of Kupo-Kupo on the opposite page is one of John Doidge's favourite photographs. And orang-utans are John's favourite subjects. That's because they're so like humans.
John does not aim to be an expert naturalist or a 'scientific' photographer; he prefers to catch 'human' moments like this.
He had waited two days on an assignment at the zoo when he suddenly saw this shot. He says that he would gladly have waited another ten days. But the moment never repeats — John has never seen Kupo-Kupo sit quite like this again.

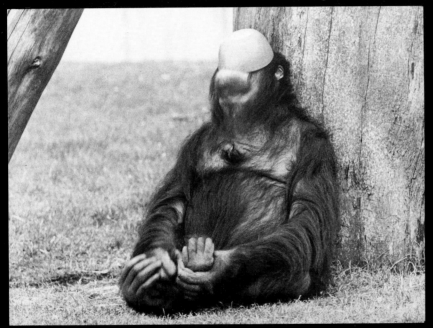

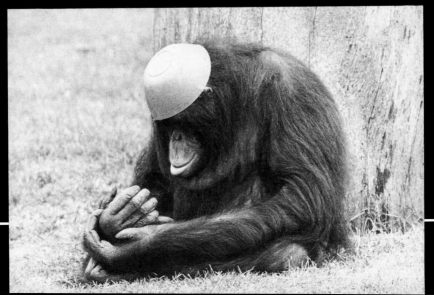

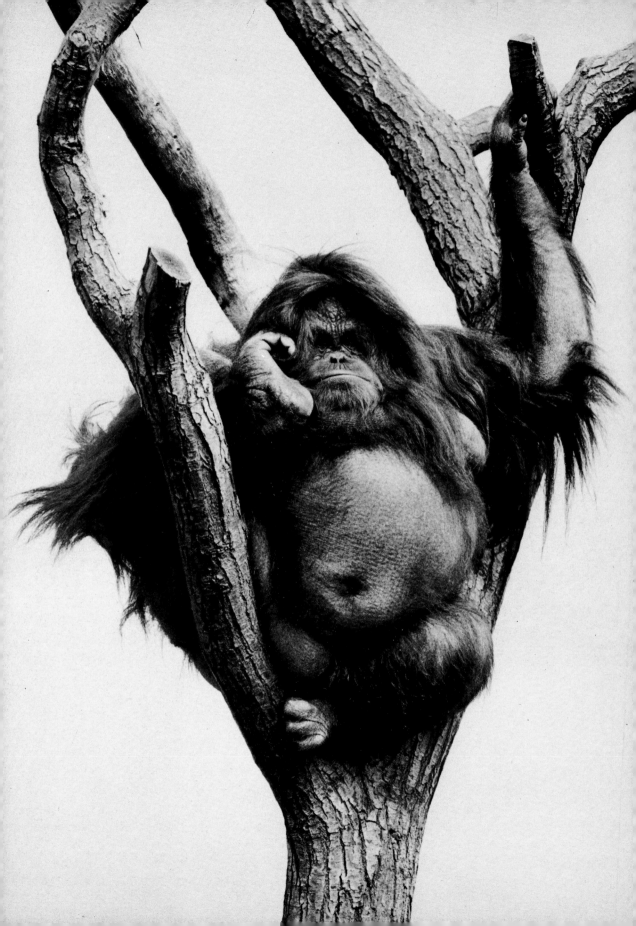

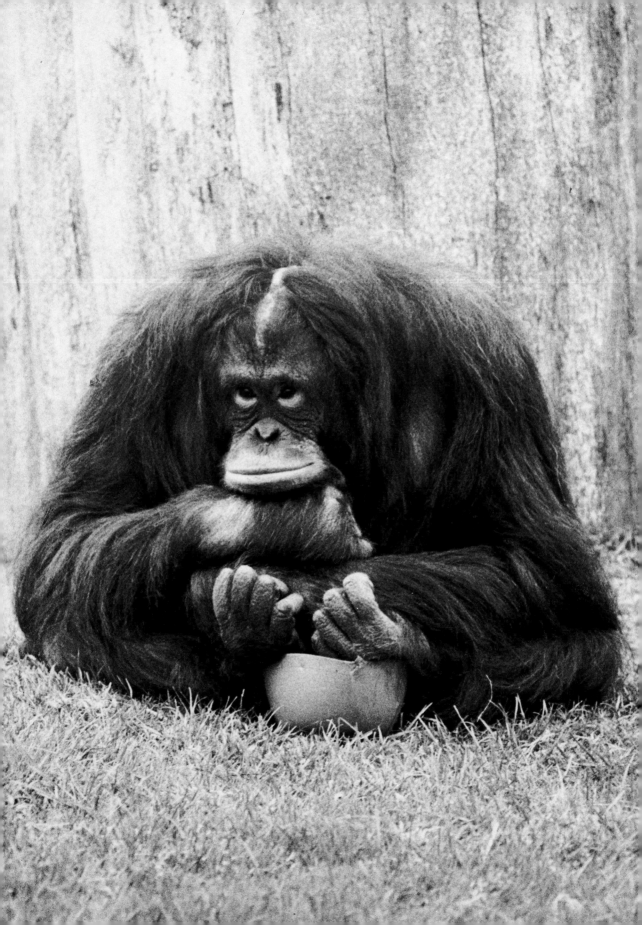

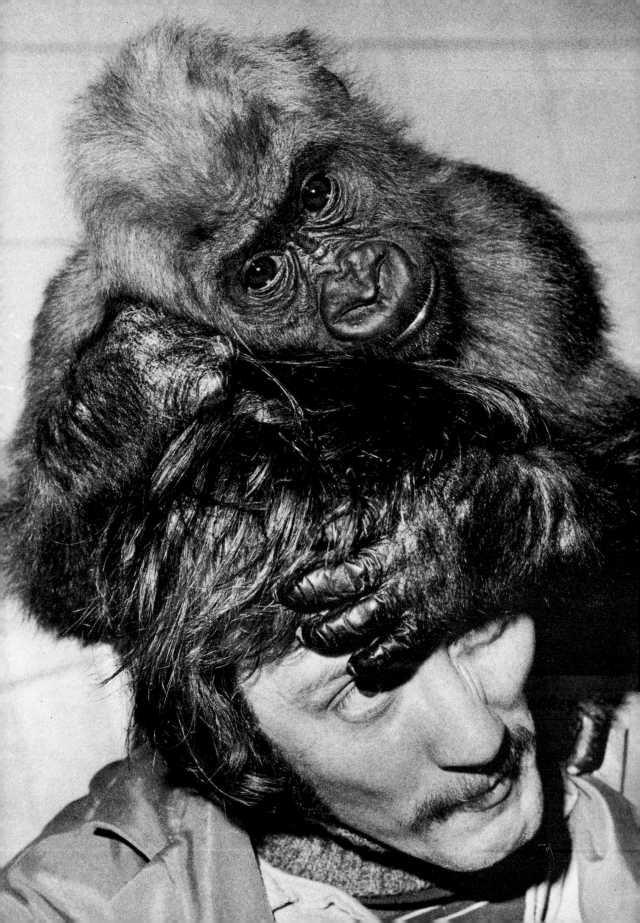

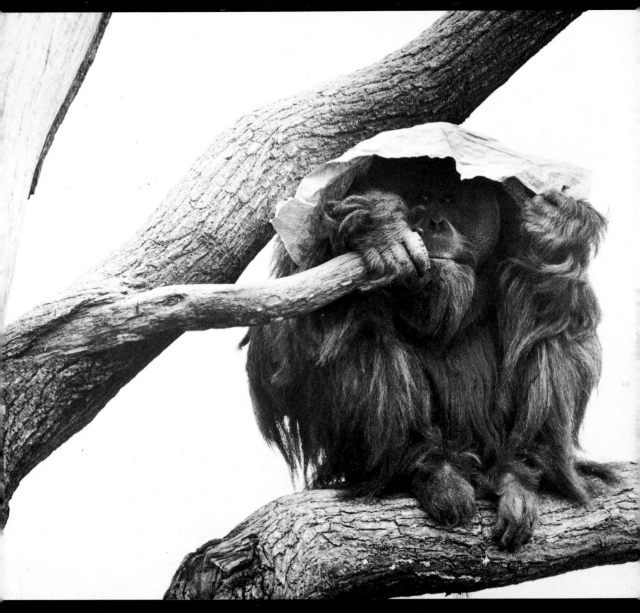

Monkey business

Toby the sentinel orang-utan is very inquisitive and he likes to shin up to his crow's-nest in the trees to spy out what's new. If it's raining — simple — he swings down for a sheet of brown paper from his den and shelters underneath it, for all the world like an old man huddled over a brazier. No one taught him this trick — it's entirely his own idea.

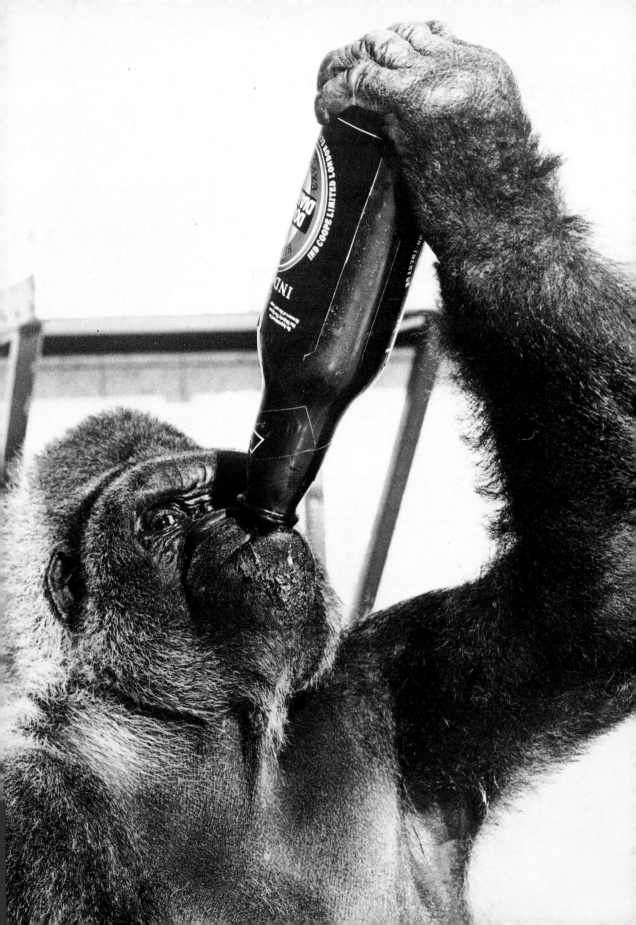

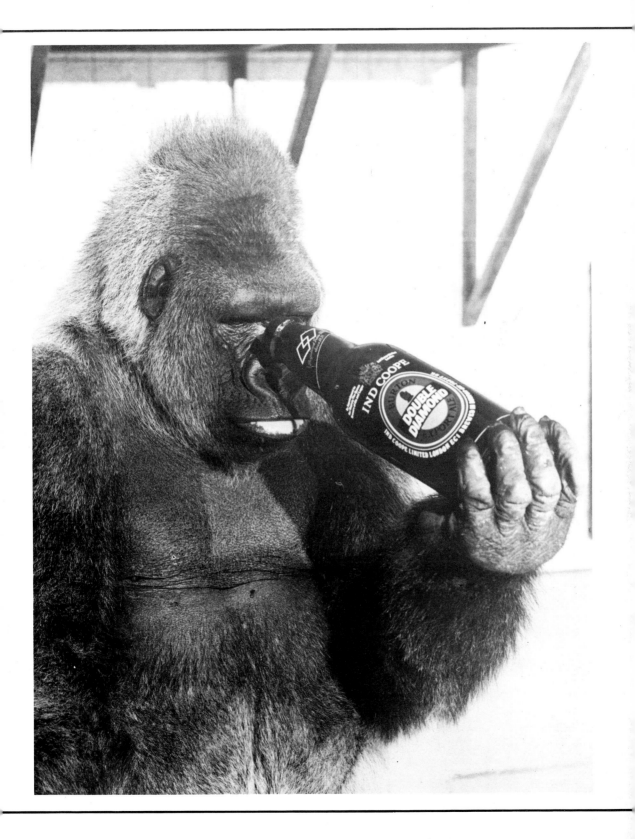

Stable companions

Racehorses are highly-strung aristocrats, who live on their nerves. They are stoked up with as many oats as they can eat, and galloped and galloped on the rolling hills. Small wonder, then, that they start to fret and develop bad habits when they are shut away in their stalls. Sometimes the valuable colts wear a path in their straw, prowling round in circles all night and never lying down for the rest they need. Or they "weave", shifting their feet up and down, and rocking their heads from side to side.

For centuries, trainers have known that the best way to calm a horse down is to give him a pet of his own – a cat, a dog, or even a chicken which might fly in by chance one day and roost in the warm hollow of his back.

The great Red Rum had a scruffy donkey chum called Andy to spend holidays with him out in the fields. He grew so attached to Andy that he used to dig his toes in and refuse to be led away from him at night – so in the end his trainer, Ginger McCain, let him stay out under the stars.

Champion steeplechaser Arkle's special girlfriend was an old grey hunter mare named Meg. Every summer, when he had finished racing, they met up again and roamed around the "Garden Paddock" at Bryanstown in Ireland. When he died in 1970, Meg, his faithful companion, did not long survive him. A few months later, she was buried beside him.

Life savers

When Colonel Gordon of Quillon was swimming one day, his dog saw a crocodile and barked violently to warn the colonel. His warning went unheeded, so the dog jumped in the water between master and crocodile – he lost his own life and saved that of Colonel Gordon.

A dog who lost his life heroically was Cracker, the pet of Earl

Brice of Nassau in the Bahamas. One day as Mr. Brice drove off to work, Cracker ran next to the car, jumping and barking and forcing Mr. Brice to keep his speed down. Cracker was knocked repeatedly, and eventually Mr. Brice stopped. At the back of the car he found Beverley, his three-year-old daughter, clinging to the bumper. Three days later Cracker died; Beverley had escaped serious injury.

Another rescue took place in Malmo, Sweden in 1977. Mr Leif Rongeno reacted with terror when he saw his two-year-old daughter, Anneli, on the window ledge, thirty-six feet above the ground. She was four feet along the ledge and behind her was their German shepherd dog, Roy. While the father seized a bedspread and ran downstairs and his wife called the fire department, Roy followed little Anneli. Then, suddenly, Roy grabbed her by her skirt and shuffled back slowly, taking Anneli to safety.

There are countless stories of dogs who have saved their owners from being burned to death in fires. For example, one of them, called Sandy, was presented with a "Services to Humanity" certificate by the British Canine Defence League when she saved her owners by climbing a flight of stairs, despite suffering from crippling arthritis in both her back legs.

But many other kinds of animals, including horses, parrots, cats and dolphins have saved people's lives. Just one example is of a cat which saved the life of its owner, a Mr George Young of Driffield in the north of England, when his house caught fire. Mr. Young was on the point of being suffocated, but his cat pushed open the door and pawed Mr. Young's face to rouse him.

Dolphins are especially well-known for saving the lives of drowning people. Recently three children on the passenger liner Tampomas II that sank, killing 140 people, were rescued when dolphins pushed them towards a lifeboat.

Friends

Paladin thinks it's fun having Mooney the mongrel as his jockey. None of the other horses in the field will let Mooney sit on them. Just Paladin.

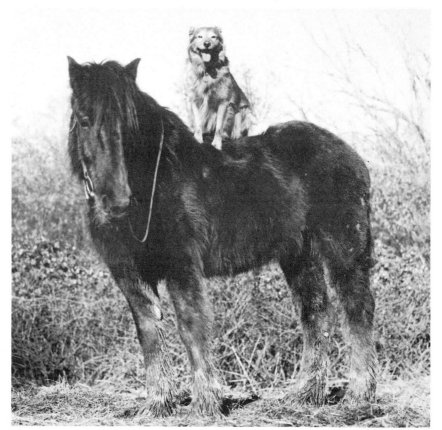

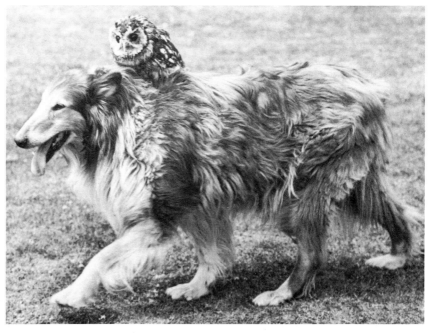

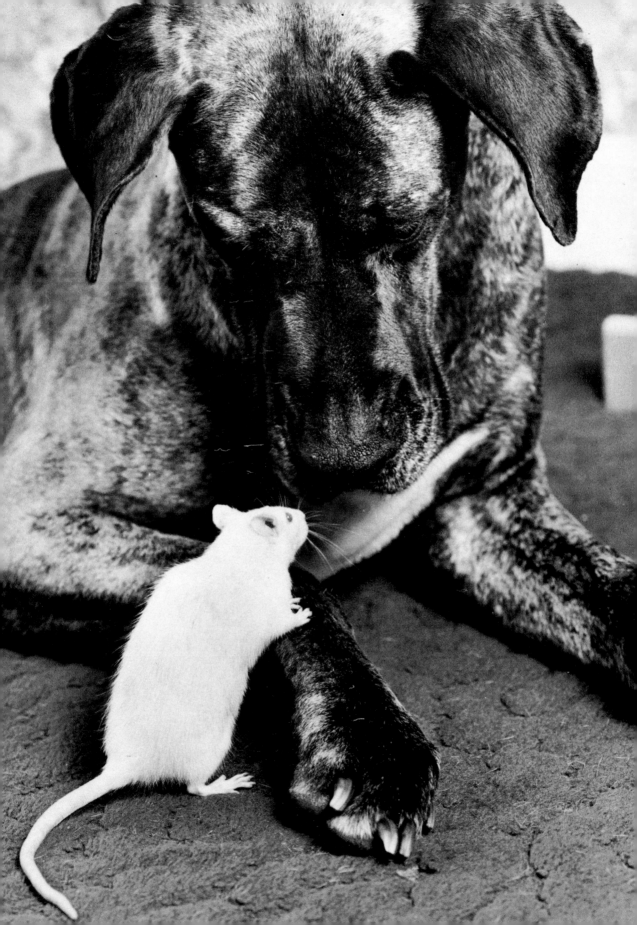

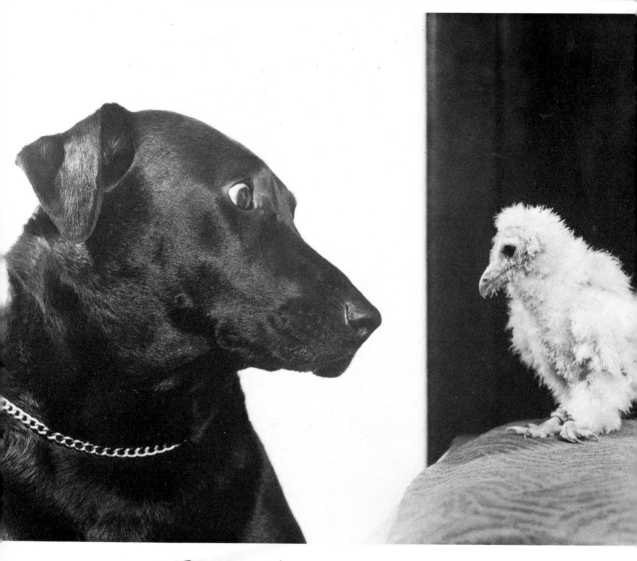

Foster mother

Mitzie never knows what pathetic little orphan her owners, Mall and Geoff Masson, will bring to her next. Like Mitzie, they don't like to turn any animal away, and have built up a sizeable menagerie at their home in the Leicestershire village of Sheepy Magna. They have a one-eyed Fox Terrier called Ginger, a Persian cat, a mouse, four chipmunks, two talking Mynah birds, three canaries and a rook recovering from a broken wing.

Mitzie is quite a fierce-looking dog — but she can't resist babies, and would never dream of harming some helpless fledgeling or fawn entrusted to her care. Kidnapping might be more in her line.

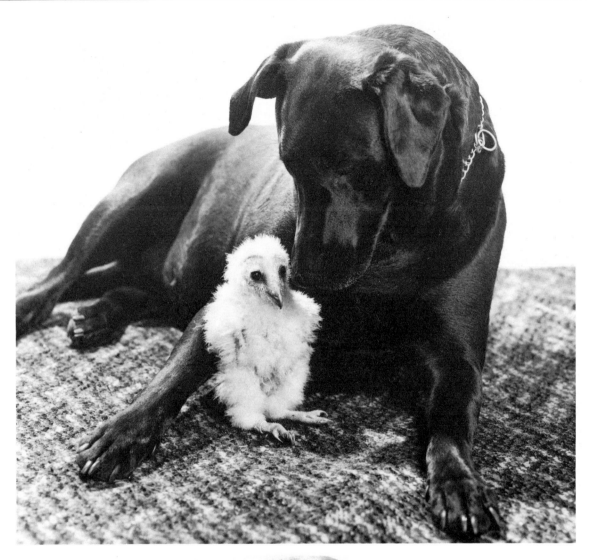

She is so gentle that all baby
animals snuggle up to her, and the
mothering instinct is so highly
developed in her that she will
gladly accept the most unlikely
'offspring'.
Buzby, a cheeky six-week-old
barn owl, feels as bold as brass
when he looks out at the world
from the safety of Mitzie's paws.

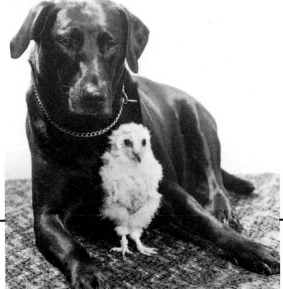

'That's my bunny'

The adoption of Tuesday, the wild rabbit, was entirely Bamba's own idea. The beautiful three-year-old Red Setter is the pet of the Walker family who live in the village of Shrawley, near Stourport, Worcestershire. One Tuesday he went out exploring and came back with the baby rabbit in his mouth; it was blind and hairless and totally helpless. Bamba deposited the limp bundle on the mat, looked up plaintively, and made it perfectly plain, in the way of dogs, that he considered Tuesday was his bunny, but that he'd appreciate a spot of help with feeding him.

The three Walker sisters, Andrea (9), Linda (17), and Jenny (19)

couldn't resist Bamba's eyes, even though bringing up Tuesday meant feeding him sweetened milk every two hours, not forgetting the nights. As the baby rabbit put on weight, grew cheeky, and learnt how to wash his whiskers, he lost all taste for the wild and preferred the comfort of Bamba's bed.

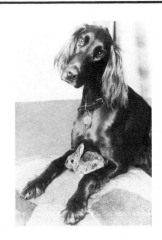

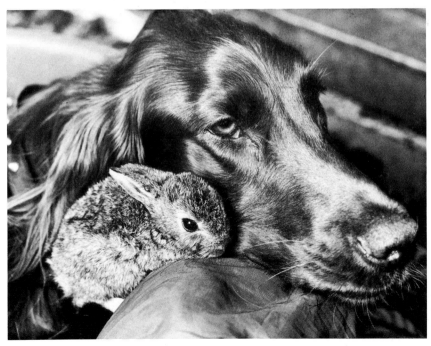

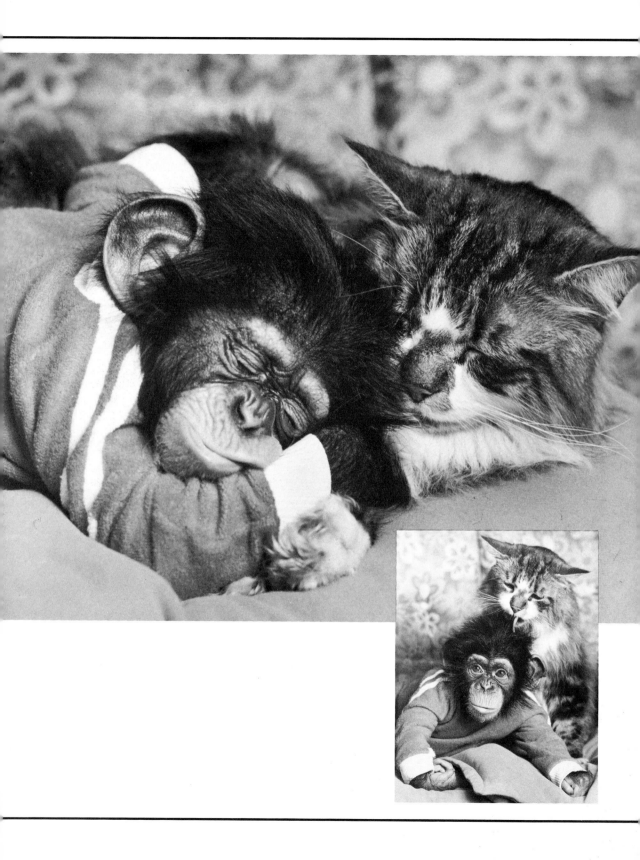

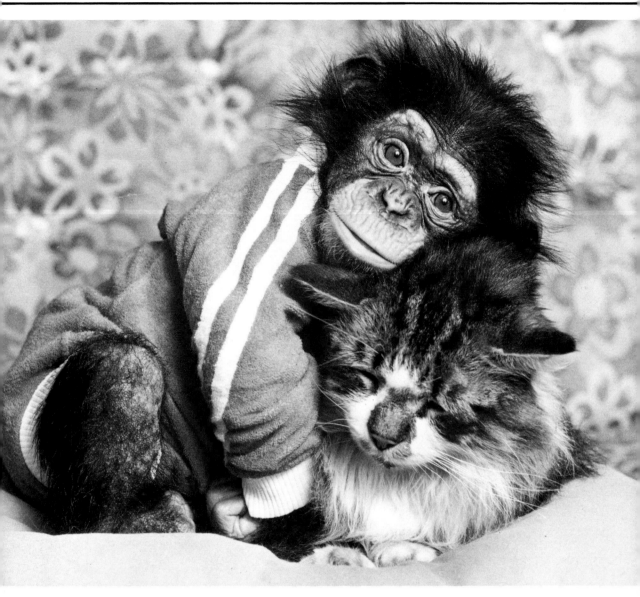

'My mummy'

Gemma's real mother was so old — a geriatric chimp — that it was a miracle that Gemma was born at all. She rapidly decided that bringing up baby was no task for a grandmother, and abandoned her. Luckily, Gemma is too young to remember, and is quite convinced that her proxy-mother, a gentle cat, is her own mother.

Animals: going...going...gone

It was a lighthouse-keeper's cat which is said to have exterminated the entire population of the pretty little Stephen Island rock wren in New Zealand. The species was last noted in 1894. But before condemning the cat, we should blame the lighthouse-keeper. In his natural desire for a pet, he upset the feather-light balance of nature. We are now beginning to realize that by creating a planet dominated by man, we are sacrificing the survival of the other myriad and marvellous species.

Sir Peter Scott, the celebrated painter and wildlife conservationist, has formulated the "four pillars of conservation": wildlife should be preserved on earth for moral, aesthetic, research and economic reasons. From the humblest hyena to the lion, many, many animals are at risk or already doomed. Over 130 mammal and bird species are already known to have become extinct. And 240 more are in danger of extinction today.

Man's exploration has lead to the extinction of the Falkland wolf, the Carolina parakeet, the quagga, several Galapagos giant tortoises, the sea mink, the passenger pigeon and many others. Man's activities are directly responsible for three-quarters of the destruction of all extinct or endangered species and have caused the erosion of the animals' environment, pollution, over-hunting for flesh, fur or horn, the introduction of alien species and even intrusion by well-intentioned tourism. Unfortunately, tourists are often ignorant of legal controls in wildlife and return from a trip with souvenirs such as cat skins, ivory and stuffed turtles.

The hunting of seals has endangered several of their species, and led to the extinction of the Caribbean monk seal. Commercial hunting began in the eighteenth century and the seal slaughter still continues to this day.

The black rhinoceros – almost certain to become extinct – is still poached for its horn which is used for items such as dagger handles, "aphrodisiacs" and cups. Luxury products which have threatened various species include furs, tortoiseshell combs,